IMAGES
of America

HARRISON COUN

IMAGES
of America

HARRISON COUNTY

Robert F. Stealey

ARCADIA

Published by Arcadia Publishing,
an imprint of Tempus Publishing, Inc.
2 Cumberland Street
Charleston, SC 29401

Printed in Great Britain.

Library of Congress Catalog Card Number: 00-106470

For all general information contact Arcadia Publishing at:
Telephone 843-853-2070
Fax 843-853-0044
E-Mail sales@arcadiapublishing.com

For customer service and orders:
Toll-Free 1-888-313-2665

Visit us on the internet at http://www.arcadiapublishing.com

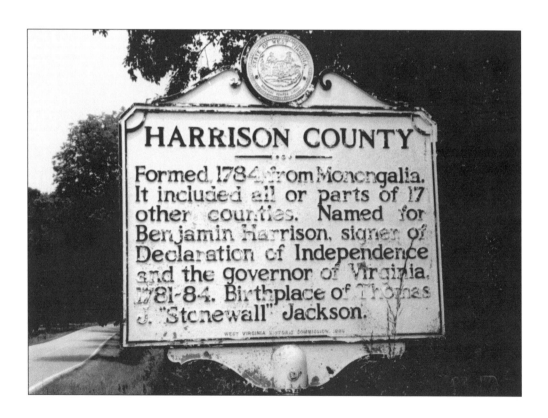

CONTENTS

ACKNOWLEDGMENTS

The photographs and illustrations that follow in *Images of America: Harrison County* have been received from numerous sources, including the author's own collection. Other sources that have provided images used in this work are hereby acknowledged. Images that appear are from both original prints and from copies of the originals. None have been taken directly from other books or publications, although some images may have coincidentally appeared in other works.

The main contributors include the following: Robert Nichols of the Bell Studio in Bridgeport, West Virginia, who provided the cover photograph and many others; Rod Rogers of the Harrison County Historical Society, who also provided images from his vast John W. Davis 1924 Presidential Candidate collection; Virgil LaRosa, who heads the Glen Elk restoration project now underway; Philip Podesta, whose prints hang in the Philip's Restaurant banquet hall; John Tate of the Shinnston area; and numerous others who made images available for use.

Information used to complete this work was derived from two noted books—*History of Harrison County* by Dorothy Davis, copyrighted in 1970 by the American Association of University Women and published by McClain Printing Company of Parsons, and also *Making a State* by Edgar B. Sims, published in 1956 by the State of West Virginia—although nothing was directly quoted from either resource.

I would also like especially to thank my wife, Nadine, plus all the other individuals who put up with me during the compilation of this book, especially my editor, Christine T. Riley.

INTRODUCTION

More than any other county in North Central West Virginia, Harrison County has the "bragging rights" to being the crossroads of the region. Clarksburg, the county seat, is located approximately 115 miles south of Pittsburgh, Pennsylvania, and about the same distance northeast of Charleston, the capital of West Virginia. To the west, the Ohio River flows past Parkersburg just 75 miles away, and Washington, D.C. to the east, is an estimated 220 miles away.

Glass manufacturing, coal mining, natural gas, and the railroad industry were for many years the chief business interests of Harrison County, and Clarksburg was long the site of two general medical hospitals and the Veterans Administration Hospital. Salem, in western Harrison County, was the home of Salem College (now Salem-Teikyo University), the only four-year institution of higher learning in the county. Salem College was founded by officials of the Seventh Day Baptist Church.

Long before West Virginia became the 35th state to join the United States, it seceded from Virginia by a proclamation of our 16th president, Abraham Lincoln, in 1863. Harrison County was part of Monongalia and Augusta Counties in the late 1770s.

By 1784, Harrison County was created. It took in land covering approximately one-third of the area of West Virginia as it is known today—a section comprising all or parts of 17 other counties by 1790. As of 1800, the area covered by Harrison County was considerably smaller—perhaps only one-fifth of the area of present-day West Virginia and from only 10 counties. There was little change in the geographical size of Harrison County until nearly 1820, when there was yet another decrease in its territorial boundary. Parts of Marion, Doddridge, Barbour, and Taylor Counties were the only areas outside of the county's current boundary at that time. The boundary of Harrison County again went unchanged until 1850 when the county was further decreased in size. By 1871, Harrison County finally reached its current geographic size. The county was named for Benjamin Harrison—not the 23rd president who served from 1889 to 1893, but a signer of the Declaration of Independence and the governor of Virginia from 1781 to 1784, more than 100 years earlier.

Harrison County is the birthplace of several well-known Americans, most notably Confederate Army General Thomas J. "Stonewall" Jackson on January 21, 1824, whose actual site of birth is marked by a plaque on a building on West Main Street in downtown Clarksburg, half a block from the Harrison County Courthouse. It is noteworthy that it was in 1863, the year West Virginia became a state, that Stonewall met his fate. Taking his Second Corps

around General Joseph Hooker's Union forces at Chancellorsville, Virginia, Jackson's men struck from behind. By nightfall, Jackson went ahead of the line to scout but was shot by his own men who mistook him for the enemy. He died eight days later on May 10th, only 41 days prior to the state's birthdate. (Because there have been many illustrations and photographs of Stonewall Jackson in numerous other county-based books and publications, this book will include only minimal pictorial references to that great American.)

Among other prominent native Harrison Countians are Cyrus Vance, the secretary of state under the 39th President Jimmy Carter; oil wildcatter Michael L. Benedum of Bridgeport; authors Melville Davisson Post, Granville Davisson Hall, and Julia Davis; and John W. Davis, the Democrat nominee for president in 1924, to name but a few. Davis Grubb, the author of *Night of the Hunter*, was born outside of the county but spent much of his life in Harrison County.

In addition to the uniqueness of its many proud accomplishments and well-known natives, Harrison County has also been the scene of a number of natural disasters, fires, and other tragedies. Most memorable to those still living and residing in the county are the November 1985 flood, the Shinnston tornado of June 1944, and the November 1950 snowfall that dumped in excess of 4 feet of the white stuff on Harrison and surrounding counties.

Now, experience more of the rich history of Harrison County in images, many of which have never before been published.

Robert F. Stealey

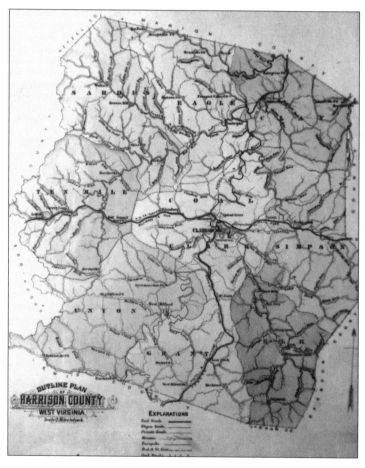

One

COMMUNITY PRIDE

Harrison County's seat of government, Clarksburg, is located roughly in the geographic center of the county. Because of that location, there are a number of other cities, towns, and communities that surround it, some that are incorporated with town councils and others that are not. Nearby communities include Bridgeport and Anmoore to the east, Shinnston and Lumberport to the north, Salem to the west, Lost Creek and West Milford to the south, and Nutter Fort and Stonewood more centrally situated. Unincorporated communities of note include Wallace, Reynoldsville, Johnstown, Mount Clare, Wilsonburg, Sardis, Summit Park/Despard, Quiet Dell, Kincheloe, Good Hope, and Rockford. This first chapter will concentrate mostly on some of the "satellite" communities mentioned and the unique character each one has. While Clarksburg also contains people proud of their heritage and history and the accomplishments throughout the years, more about that city will appear in subsequent chapters.

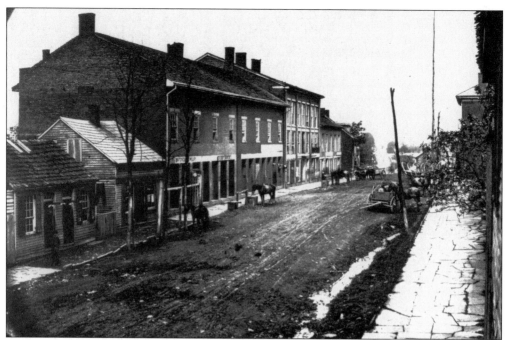

Main Street in Clarksburg in 1863 is shown in this photograph taken by Bennett Ryder. The second building from left is the birthplace of Confederate Army General Thomas J. "Stonewall" Jackson, arguably Harrison County's most famous native-born son. (Courtesy of the Harrison County Historical Society.)

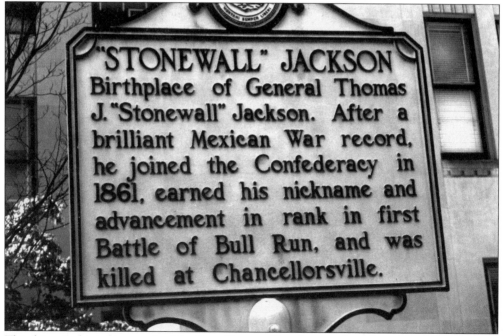

This historical marker on the Harrison County Courthouse plaza faces West Main Street in downtown Clarksburg and briefly summarizes the remarkable military career of Stonewall Jackson.

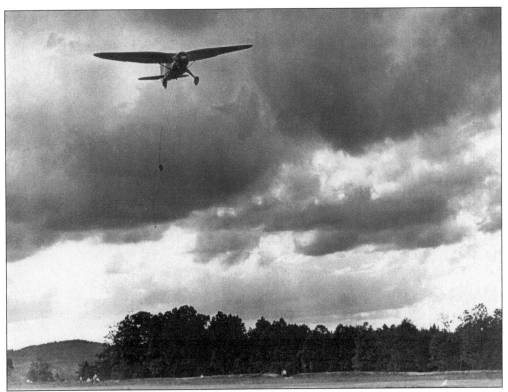

One of the first aircraft to regularly fly over Harrison County was this Stinson plane preparing to make a mail drop and photographed in the early 1940s over what is now Benedum Airport in Bridgeport. AeroMech was West Virginia's first airline and once had 18 flights arriving in and leaving Harrison County. (Courtesy of Angelo Koukoulis, founder of KCI Aviation.)

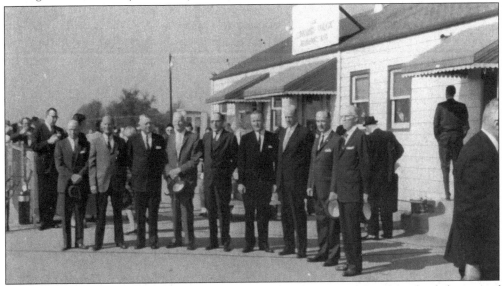

In the early 1950s, a number of county and state dignitaries were on hand for the dedication of the very first terminal building at Benedum Airport. It was replaced years later by a two-story facility. (Courtesy of Angelo Koukoulis, founder of KCI Aviation.)

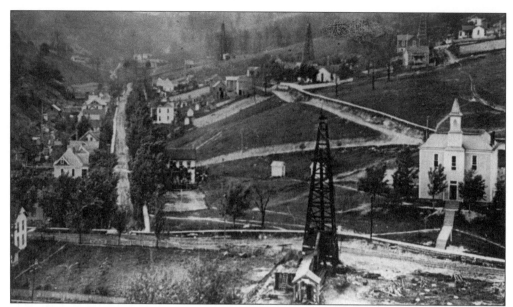

In the very early days of Salem College, numerous oil wells towered over the town and the campus, which was limited (in this 1889 view) to the steepled building on the right. The college was founded by officials of the Seventh Day Baptist Church. (Courtesy of Bob Nichols of the Bell Studio in Bridgeport, who has prints of the photos he provided for this work on his website, The Bell Studio.com.)

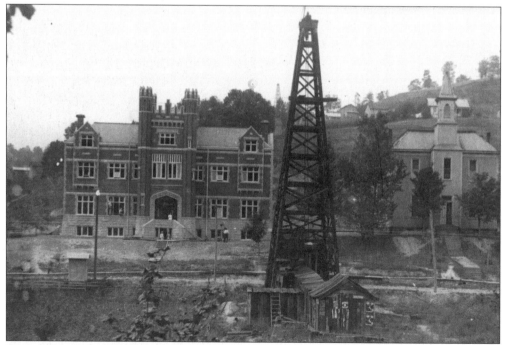

Some of the oil wells did remain, but Salem College added a new administration building several years later, some time between 1911 and 1914. The building at right was destroyed by fire in 1914. The college would soon begin to expand, and today, having merged with Teikyo University in Japan, is known as the "Valley of Learning." (Courtesy of Bob Nichols.)

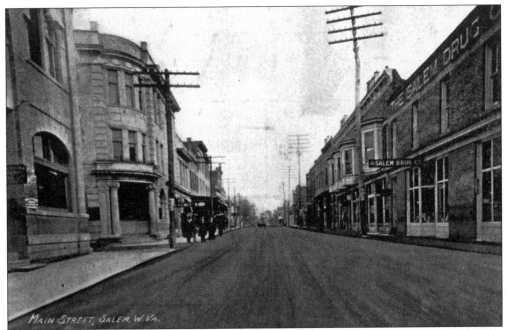

Main Street in Salem in the first quarter of the twentieth century is shown in this view, which looks eastward and appeared on a picture postcard that carried a 1908 postmark. The Salem Drug Co. was located on the right, and a bank is shown on a street corner at left. (Courtesy of Mrs. J.R. Eddy of Clarksburg.)

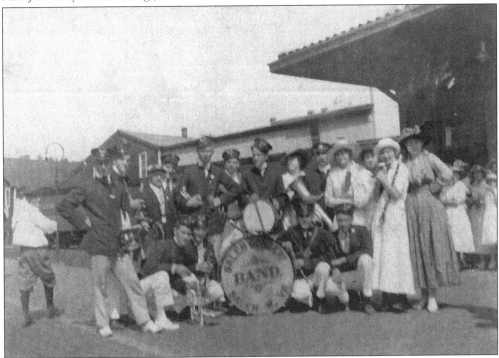

Members of the Salem Concert Band are shown in this 1912 photo. Many of the members of the band were of Belgian descent. (Courtesy of Vicki Zabeau Bowden.)

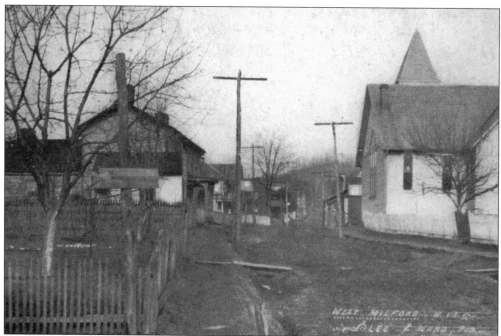

This is Main Street in West Milford as it appeared just after the turn of the twentieth century. The photograph was taken from a site that is now the street's intersection with Liberty Street. Note the utility line shown running just beneath the surface of the earthen roadway. (Courtesy of Bob Nichols.)

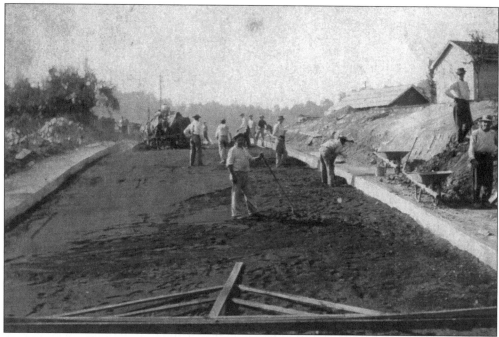

The paving of Main Street in West Milford was made possible by the efforts of these workers, one of whom was Emile Houillet. Sidewalks were already in place when the paving was completed. (Courtesy of Bernice Houillet of Clarksburg.)

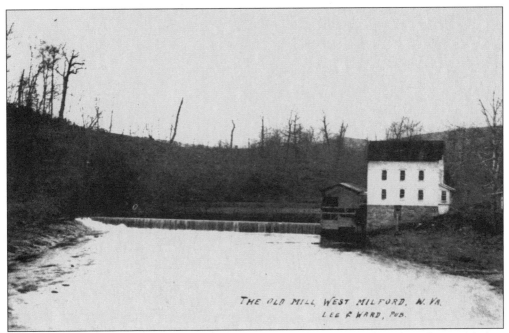

The Old Mill at West Milford is where settlers crossed the West Fork River. The river below the dam was so shallow that settlers could ford the stream. "Mill-ford" became part of the name of the new town. (Photo by Lee & Ward, Pub; courtesy of Bob Nichols.)

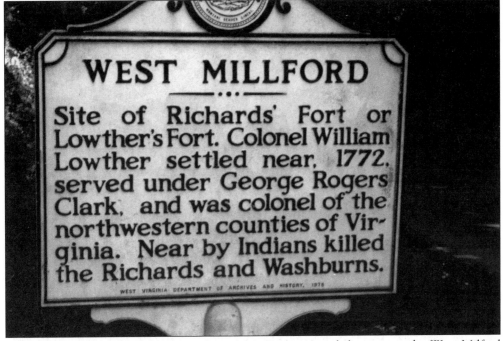

Northbound and southbound motorists on U.S. Route 19 and those using the West Milford cutoff (WV Route 270) pass this sign that provides a thumbnail summary of the story of the settlement by Colonel William Lowther in the late eighteenth century. The spelling of West Millford was officially changed to West Milford.

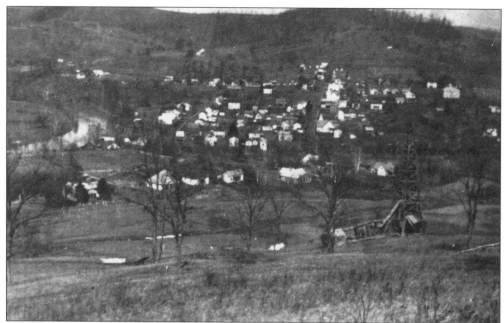

This is a bird's-eye view of West Milford in the town's early days. Note the bend in the West Fork River toward the left of the photo; that bend is a short distance from Route 19. (Courtesy of Bob Nichols.)

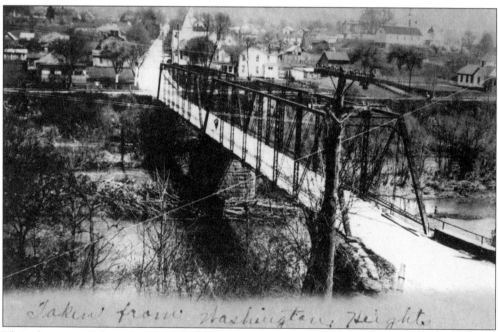

This photo was believed to have been taken shortly after 1900 in the Washington Heights section of West Milford and shows the old steel bridge that spanned the West Fork River throughout much of the twentieth century. In the background is Main Street. (Courtesy of Bob Nichols.)

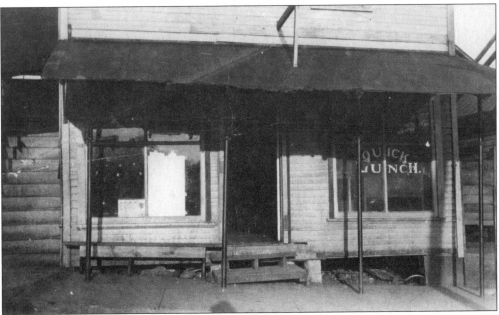

Some folks familiar with the West Milford of yesterday will recall the Quick Lunch restaurant on Main Street in this 1920s photograph. The business was famous for the many domino games that were played there on wire-legged tables on warm summer afternoons. (Courtesy of Bob Nichols.)

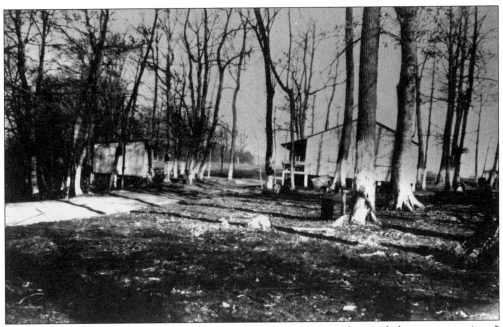

This scene shows a camp house at Laurel Park in a predominantly wooded section just 4 to 5 miles south of Clarksburg. This early 1900s photo was taken on a snowless winter day. Though still largely rural, the area contains a few more residences today. (Courtesy of Bob Nichols.)

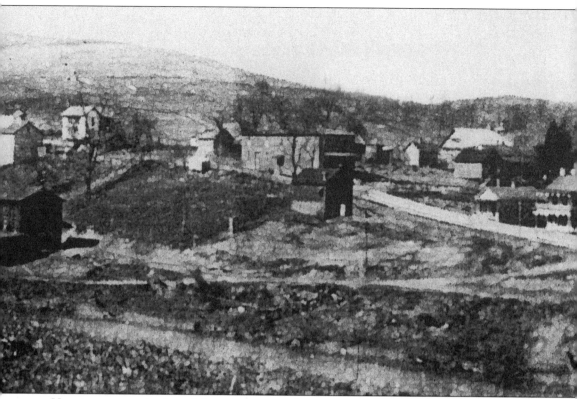

Here is a panoramic view of the unincorporated community of Sardis in northwestern Harrison County, photographed not long after 1900. Note the three-story building in the extreme lower left corner of the picture. It was the last operating gristmill in Harrison County. It was

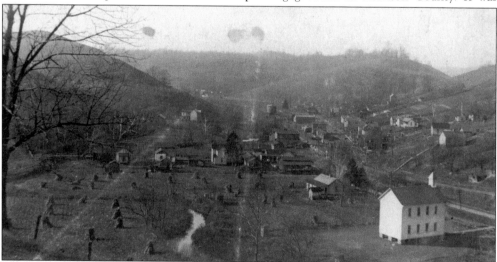

The community of Bristol, located about 4 miles east of Salem, is seen in this turn-of-the-century bird's-eye view. Bristol High School was also in the community but is not shown here. Bristol High School students were consolidated with those from Salem and Victory High Schools to form Liberty High School. The old Bristol Grade School is at the right of the photo. Little remains of what was once Bristol. (Courtesy of Bob Nichols.)

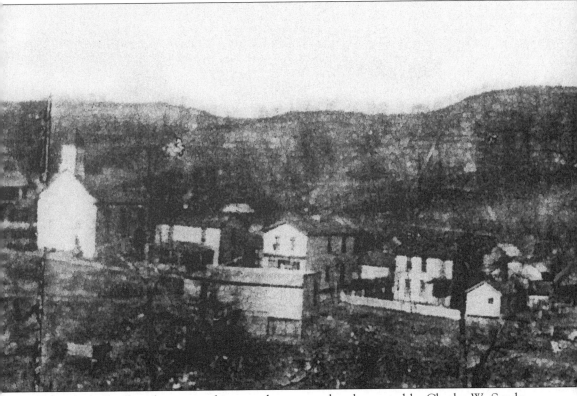

steam-powered rather than water-driven and was owned and operated by Charles W. Sandy, whose grandson, Ron Sandy of Clarksburg, provided the picture.

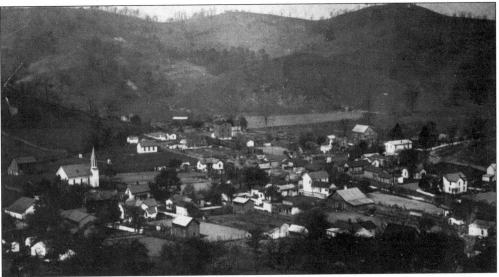

Rolling hills provide the background for this view of the Town of Lost Creek, incorporated in 1946. Lost Creek was a crossroads of sorts in southern Harrison County, with West Milford to the west and Rockford and Johnstown to the east. It is today easily accessible via Interstate 79. Nearby is South Harrison High School. (Courtesy of Bob Nichols.)

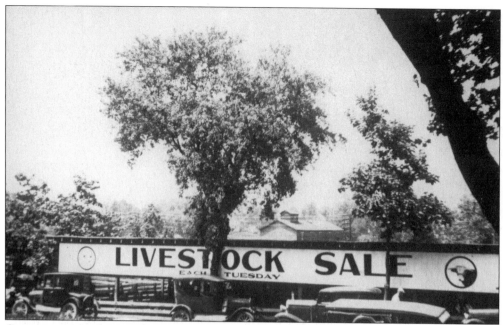

Quite an active place in the center of Bridgeport, the Bridgeport Stockyards attracted cattle farmers from miles around. Livestock sales were first held on Tuesdays. This is a view looking westward. (Courtesy of Bob Nichols.)

A number of cattle dealers must have been busy at this livestock sale at the Bridgeport Stockyards seen in this view looking eastward toward the railroad crossing in Bridgeport. Judging by the vehicles in the parking area, the photo was likely taken some time in the 1930s. (Courtesy of Bob Nichols.)

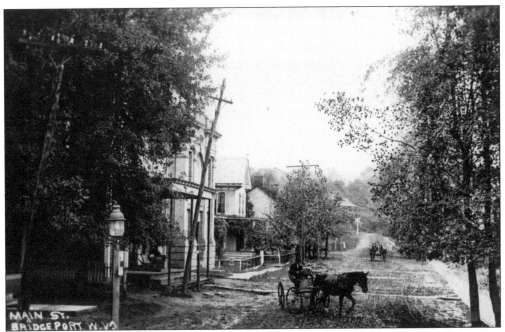

In this view of early twentieth century Main Street in Bridgeport, a careful glimpse will reveal the Bridgeport Bank building at left. The railroad crossing, which exists today despite the lack of railroad traffic, is in the background toward the right. Note the gas lamp and the horse-drawn buggies. (Courtesy of Bob Nichols.)

This house at the corner of West Main Street and Virginia Avenue in Bridgeport is a familiar landmark in that city. Originally the William Johnson home, it was acquired in more recent years by William Ferguson. It today houses an antique business. (Courtesy of Bob Nichols.)

The Green Parrot Inn in the west end of Bridgeport provided dining and dancing, as well as lodging cabins in the late 1930s and early 1940s. It was a quite popular place to go in the Bridgeport area at the time. (Courtesy of Bob Nichols.)

The sign of the Green Parrot at far left was virtually all that had gone unchanged at the Green Parrot Inn when this photo was taken in 1962. The cabins outside continued to accommodate tourists until the Green Parrot was demolished in the early 1970s. (Courtesy of Bob Nichols.)

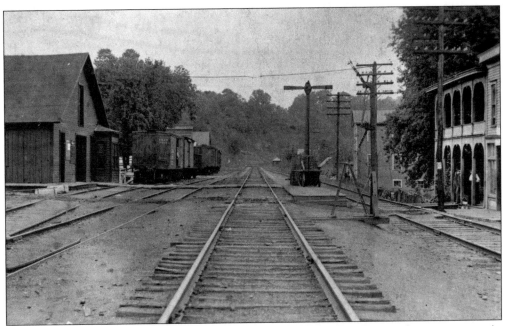

The Baltimore & Ohio Railroad track ran east to west through Bridgeport for many years. At left is the Baltimore & Ohio depot, as seen in 1911. The arch-pillared building on the right is the old Commercial Hotel. (Courtesy of Bob Nichols.)

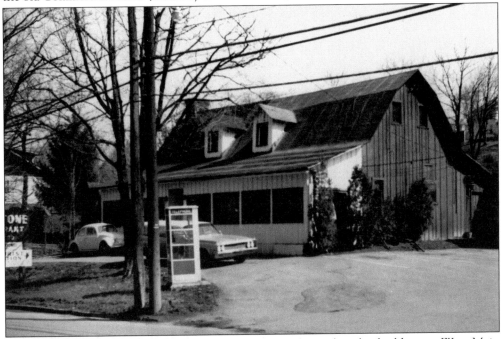

A number of businesses, mainly restaurants, have been located in this building on West Main Street in Bridgeport. Formerly owned by J. Eddie Sheets, who owned J. Eddie's Candies across the street, Millstone Restaurant is pictured here in 1962. It later became the Bavarian Restaurant. The structure has also housed the Bell Studio, a pharmacy, and, currently, a bicycle shop. (Courtesy of Bob Nichols.)

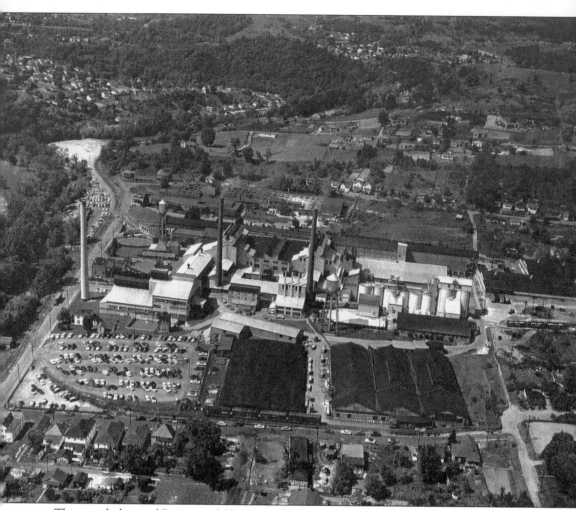

This aerial photo of Stonewood (foreground) and Nutter Fort (left, background) is dominated by the Pittsburgh Plate Glass Company, later PPG Industries, which closed in the early 1970s after many years of providing economic support to Harrison County and Central West Virginia. Water Street in Stonewood is shown at left. The complex would later become the Stonewood Industrial Park. Norwood Park, now Clarksburg City Park, is located across Elk Creek, but is not visible in this 1972 photo by the late Edwin G. Propst, taken when he was employed by Charles Henry of Clarksburg Engraving Co. (Courtesy of Joyce Propst.)

Although the proper name of the town, incorporated in 1923, is Nutter Fort, this historic marker indicates the spelling "Nutter's Fort." The fort was built by Thomas Nutter, for whom the town was named. The sign gives a thumbnail summary of the fort's history.

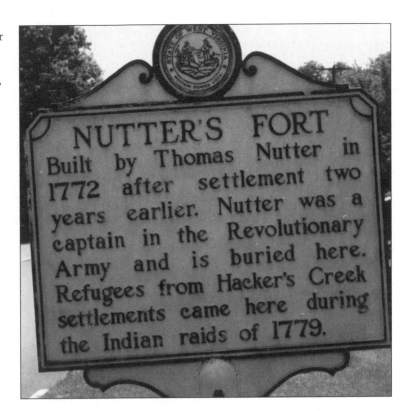

NUTTER'S FORT
Built by Thomas Nutter in 1772 after settlement two years earlier. Nutter was a captain in the Revolutionary Army and is buried here. Refugees from Hacker's Creek settlements came here during the Indian raids of 1779.

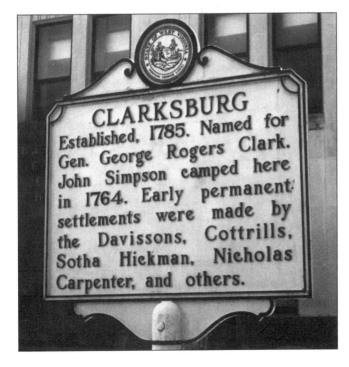

CLARKSBURG
Established, 1785. Named for Gen. George Rogers Clark. John Simpson camped here in 1764. Early permanent settlements were made by the Davissons, Cottrills, Sotha Hickman, Nicholas Carpenter, and others.

Clarksburg is the Harrison County seat, and this historical marker stands facing West Main Street downtown in front of the courthouse. As reflected in the sign, the city was established in 1785 and named for General George Rogers Clark. Clarksburg had a population of more than 32,000 in 1950.

OBERT	FRAGMIN. CARL	HEFNER.	IARLES	LORENZO. LLOYD	POSEY. JAME!
LIAM	FRAGMIN. DOMINICK	HOMICZ.	EXANDER	LORENZO. MANUEL P ★	POST. EDWAR
	FRAGMIN. DOMINICK	HOMICZ.	ANLEY	MARINO. DOMINICK ★	POTH. JOHN
RD	FRAGMIN. FRANK	HUFFORD	HARLES	MARINO. JAMES S.	POTH. PIETE
IRVIN	FRAGMIN. FRED	HUFFORD	EITH	MARINO. JOHN	POWELL. GLE
SSELL	FREDERICK. EARNEST	HUNN. BE	IAMIN	MARTIN. JAMES	PRIETO. JOS
RT	FREDERICK. JOHN	IAQUINTA	.AWERENCE	MATHENY. EDWARD	PRIETO. MIN
RL	FREDERICK. WILLIAM	JEFFERY	ARNEST	MATHENY. HARRY JR.	PRITCHARD.
RADY	GARCIA. FELIX	JEFFERY	STMER	MATHENY. THEODORE	PRITCHARD.
ARAH	GEORGE. IVAN	JEFFERY	ILTON	MAYFIELD. LEE	PRITCHARD.
OHN	GOLDEN. JAMES	JEFFERY	ILLIAM C.	McINTIRE. LEROY	QUEEN. CECI
NCE	GOLDEN. LAWRENCE	JOHNSON	EARL	McNEMAR. THOMAS	QUEEN. KENN
IS	GOLDEN. ROBERT	JOHNSON	JAMES	MILEY. TRUMAN	REED. CORL
NIEL JR.	GOLDEN. WILLIAM E.	JOHNSON	ROY	MUNIZ. JAMES H.	RENZELLI. F
RLES JR.	GONZALEZ. ANGEL JR.	JOHNSON	WILLIAM	NELSON. JOHN R.	RENZELLI. J
TER	GONZALEZ. AUGUSTINE	JONES. .	MES E.	NUTTER. ROBERT	RIBAS. ANTI
MES	GONZALEZ. JOSEPH	JONES. V	LIAM	OLAH. JOHN JR.	RIBAS. LOU
RRY JR.	GONZALEZ. LLOYD	JUNKINS	IORSEY	OVIES. MANUEL	RIBAS. MAN
HRIS	GONZALEZ. MATEO	KEISTER	ARL	OVIES. WILLIAM JR.	RICHARDS.
MIL	GRANTANO. NICK	KEISTER	IAYMOND	PAHUTA. BRONCH	RICHARDS.
RANK	GREATHOUSE. PAUL	KEOUGH.	OHN F.	PAHUTA. CHESTER	RICHARDS.
RED	GREEN. DARRELL	KESLING	ESSELL	PAINTER. WILLIAM	RICHARDS.
JOSEPH	GREEN. HARVEY	KESLING	EU MERL	PALMER. LYLE	ROWE. KE!
	BERTRAM	KESLING	ALTER	PALMER. VANCE	RUTTER. AF

Some of the many names of Anmoore citizens who gave up their lives in service to their country during World War II appear on this very special memorial that stands in front of the Union Carbide (UCAR) plant in Anmoore. Formerly known as Grasselli, Anmoore was incorporated in 1950.

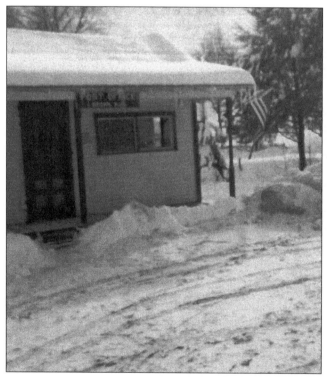

A heavy snow closed the post office, seen here, in the unincorporated community of Brown on January 28, 1966. Brown is located about 8 miles west of Shinnston in northern Harrison County, and the post office is located along WV Route 20. (Courtesy of Lowell Smith of Bridgeport.)

The concrete piers of the new Spelter Bridge are shown here during the construction of the span over the West Fork River. The bridge opened in 1962, according to Anita Menendez of Spelter, who provided the photographs on this page.

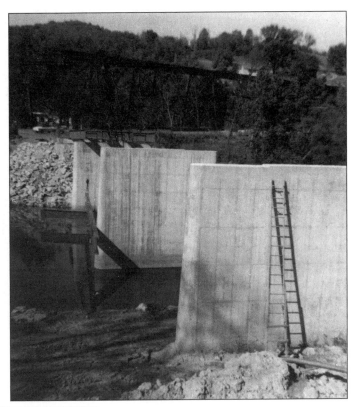

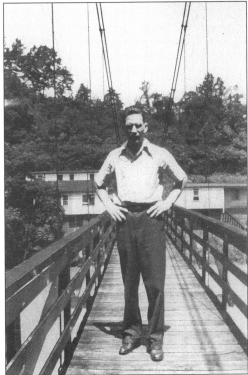

This man stands midway across the "Old Swinging Bridge" that once served the Spelter community, formerly known as Ziesing. The bridge was replaced by a new concrete span in the early 1960s.

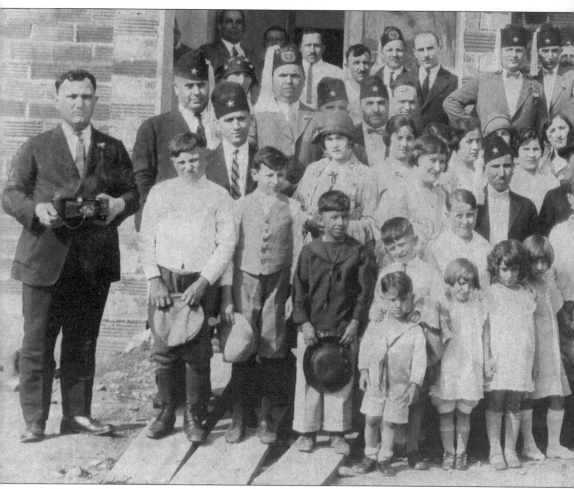

Summit Park's community center is shown being dedicated in this *c.* 1928 photograph. The center, which was located for many years next door to the St. Spyridon Greek Orthodox Church on Railroad Street in Summit Park, was demolished in 1997. More photos pertaining to

SALTWELL

Village so named because of well drilled here in 1835 by Abraham and Peter Righter. The well reached a depth of 745 feet releasing natural gas. Often attributed to be first deep well drilled in United States. Water from such wells was reputed to have medicinal value. Some salt was produced here but these efforts were abandoned as Kanawha Valley production and influence increased.

WEST VIRGINIA DEPARTMENT OF CULTURE AND HISTORY, 1982

The message on this historical marker notes the distinction of the tiny historic community of Saltwell in northern Harrison County, located 4 miles east of Shinnston. The community suffered considerable damage in the "Shinnston Tornado" of June 23, 1944.

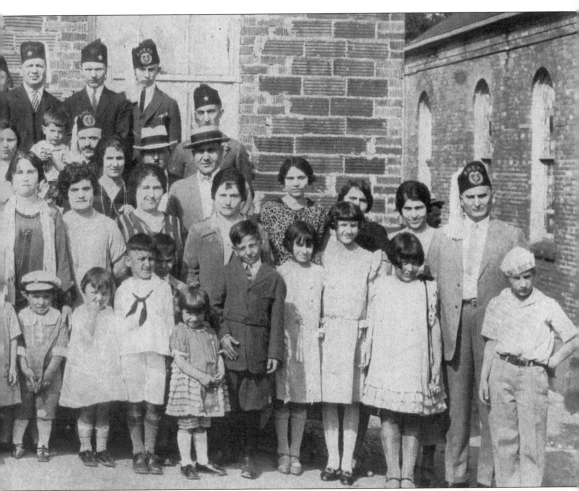

the Greek community will appear in a later chapter. (Courtesy of Angelo Koukoulis of Bridgeport.)

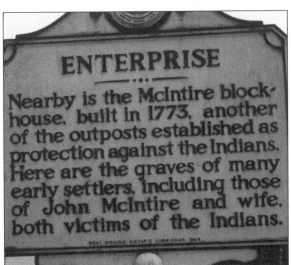

ENTERPRISE
...

Nearby is the McIntire block-house, built in 1773, another of the outposts established as protection against the Indians. Here are the graves of many early settlers, including those of John McIntire and wife, both victims of the Indians.

WEST VIRGINIA HISTORIC COMMISSION 1964

Enterprise is perhaps the northernmost community in Harrison County. Located 3 miles north of Shinnston, a brief run-down of the town's origin appears on this historic marker. A new bridge was built in the community in the mid-1980s.

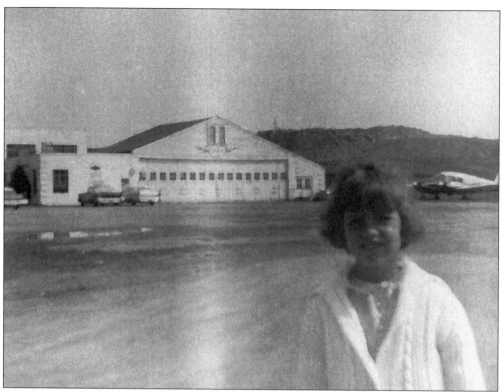

A little girl stands in front of the first maintenance hangar, built in the late 1930s, at Benedum Airport in Bridgeport. The photograph was taken some time in the 1960s. (Courtesy of Angelo Koukoulis of Bridgeport, founder of KCI Aviation, the fixed-wing facility at Benedum.)

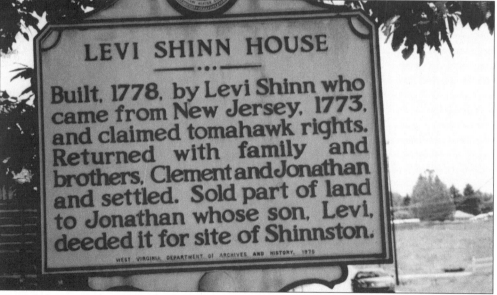

LEVI SHINN HOUSE

• • •

Built, 1778, by Levi Shinn who came from New Jersey, 1773, and claimed tomahawk rights. Returned with family and brothers, Clement and Jonathan and settled. Sold part of land to Jonathan whose son, Levi, deeded it for site of Shinnston.

WEST VIRGINIA DEPARTMENT OF ARCHIVES AND HISTORY, 1975

One of the most prominent landmarks in Harrison County and all of North Central West Virginia is the Levi Shinn House, located just south of Shinnston along U.S. Route 19. The West Virginia Department of Archives and History posted this marker in 1975.

Two

PEOPLE

OUR GREATEST RESOURCE

More than any other asset for which Harrison County is best known is its people—from the years before the War Between the States to the present day. Individuals in public service to their town and county, ordinary citizens living their everyday experiences, and people who have served in their workplaces are featured in the handful of photos on the next few pages. It is the human element—the heart, the mind, and the feelings—that separates the people from the "things." It is they who provide that extra dimension of life to the two-dimensional scenes that follow on the next several pages.

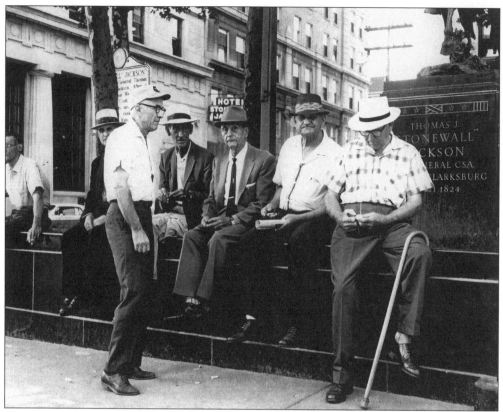

Chatting while sitting on the granite wall in front of the Harrison County Courthouse, these gentlemen enjoy the summer pastime of friendly conversation. They are seated directly in front of the statue of General "Stonewall" Jackson, truly Clarksburg's best-known "favorite son." (Courtesy of Mrs. Charles Henry of Clarksburg.)

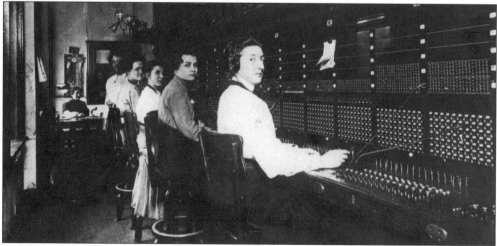

These telephone operators are shown at one of the earliest telephone switchboards to serve Harrison County. The photograph is believed to have been taken some time between 1910 and 1920. The operators' supervisor can be seen seated at a desk in the background. (Courtesy of Bob Nichols.)

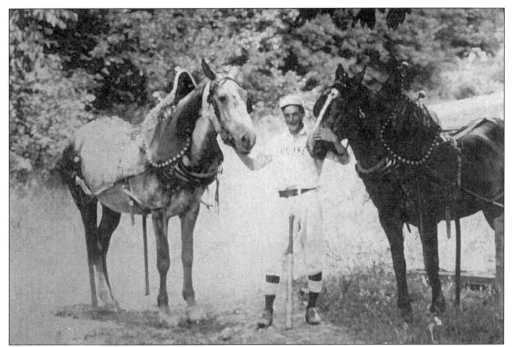

Charley Parker Smith, clad in a baseball uniform and standing between two "friends," was a teamster for Laffey Whiteman during the oil boom in the Wallace area in northwestern Harrison County. This photo was taken *c.* 1910. (Courtesy of Lowell Smith of Bridgeport.)

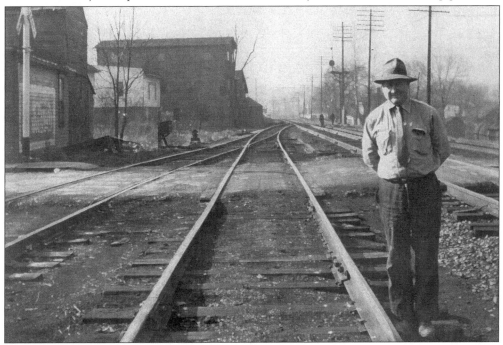

Joe Deegan, a former Bridgeport mayor, is shown standing along the Baltimore & Ohio Railroad track in the center of Bridgeport in this October 1943 photograph. (Courtesy of Alice Deegan Ulch of Tucker County, daughter of Mr. Deegan.)

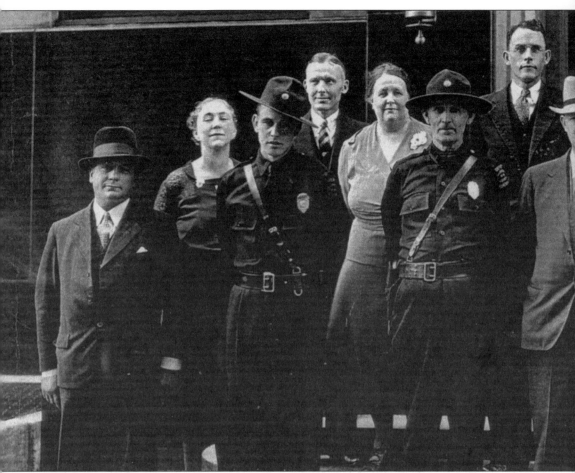

Members of the Harrison County Sheriff's Department assembled with members of the county court and other officials at the Third Street entrance to the courthouse. It is believed that the photo was taken in about 1936, which would have been only four years after the five-story

These tots enjoy the Roy Rogers kiddie train in 1950, one of several rides for children located at Warner's Skyline Drive-in Theater, located off U.S. Route 19, 4 miles south of Clarksburg. Another drive-in theater at the time, Snyder's, near Craigmoor, also offered rides to the youngsters before the featured films began.

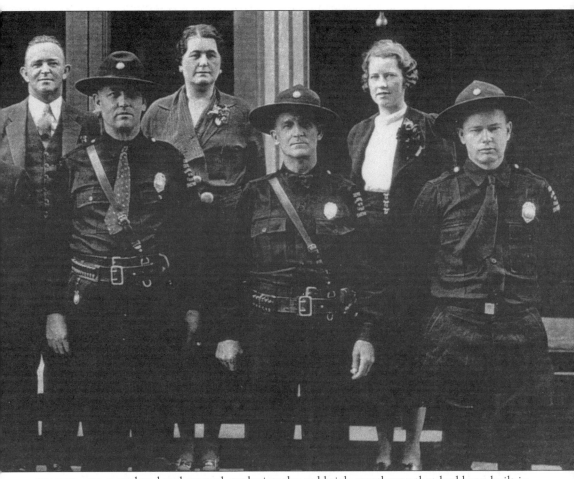

structure was completed and opened, replacing the red brick courthouse that had been built in 1888. According to information from Dorothy Davis's book *History of Harrison County*, Fitzhugh Reynolds was sheriff in 1936.

Arthur J. Thompson was a Republican nominee for the West Virginia House of Delegates from Harrison County in the early 1900s. His campaign slogan was "I stand for fewer laws, lower taxes and less expense"—something many might say we could use today. (Courtesy of Lowell Smith of Bridgeport.)

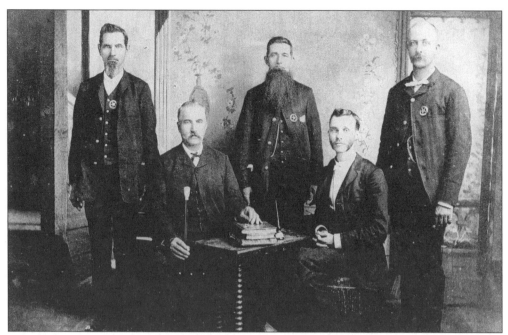

The first officials of the City of Clarksburg are shown in 1885, the year of the city's incorporation. From left to right are (seated) Enoch Tinsman, mayor; and Marcellus Thompson, recorder; (standing) James H. Jarboe, police officer; James H. Smith, town sergeant, and J.T. Boggess, policeman. (Courtesy of the Harrison County Historical Society.)

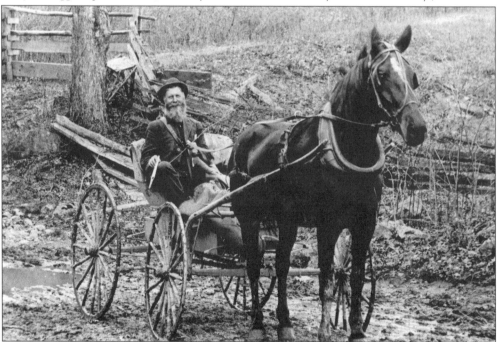

This elderly gentleman riding in his one-horse carriage was one of the very first mail carriers in Harrison County—long before the days of ZIP Codes and modern mail-sorting techniques. This photograph was probably taken some time in the late 1800s. (Courtesy of Bob Nichols.)

This picture was taken in 1922 at a mining camp in the Harrison County community of Rider, located between Lost Creek and West Milford. Pictured are Mr. and Mrs. Philip Wright and their daughters, Ruth and Thelma. Now Thelma Winning, she was the younger of the daughters and the contributor of this photo.

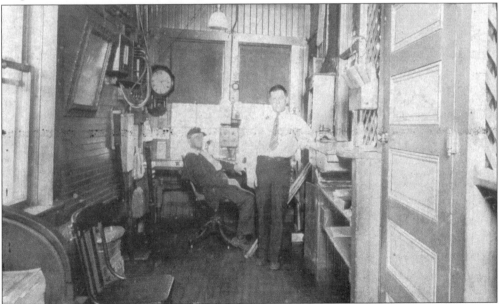

J.A. Deegan, a freight agent (standing), and W.S. Law, a telegraph operator, appear in the Baltimore & Ohio Railroad depot office in Bridgeport in this April 30, 1928 view. Law reportedly lost a leg and used a crutch to move about. The following year, the depot was destroyed by fire. (Courtesy of Miss Jessie Blackwell of Bridgeport.)

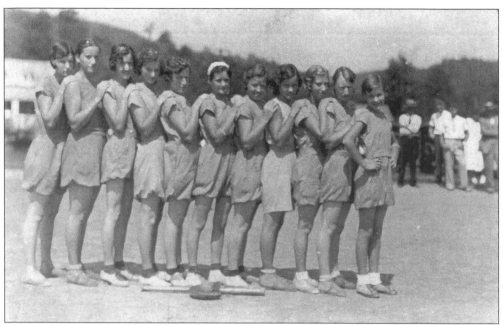

This photo was taken at Jackson's Mill in Lewis County in 1933, when the Sardis Girls Speed Ball team became state champions. Members of the team include Floriene Strother, Nola Rogers, Garnett Gerrard Lynch, Evaline Robinson Haggerty, Ernestine Harbert Schweikert, Elizabeth Hustead, Virginia Ann Rogers, Lillian Sandy, Mable Goodwin, Bernice Harbert Noe, and an unidentified player. (Courtesy of Dick and Barbara Anderson of Clarksburg.)

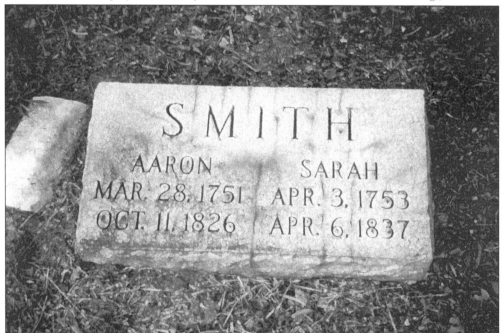

The grave of Aaron and Sarah Smith, located in the Sardis area, is shown here. Aaron, born in 1751, lived to the age of 75 and his wife, born in 1753, lived to be 84. (Courtesy of Lowell Smith of Bridgeport.)

Three

FAMILIAR PLACES
THEN AND NOW

The photos and illustrations in this chapter are intended to make Harrison County's various landmarks come alive. Whether brick or earthen streets, old automobiles or past-and-present buildings, the landmarks on the next several pages will surely prompt numerous memories. Notable Clarksburg landmarks that are still standing are featured. In addition, images of places no longer in existence help to bring a vanished past vibrantly to life.

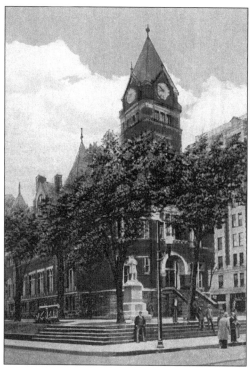

The red brick Harrison County Courthouse, known for its clock tower, was completed and opened in 1888. The building served the county as the seat of government and justice until 1932, when the current courthouse opened. This photo was taken from a postcard. (Courtesy of Eugene Jaumot of Clarksburg.)

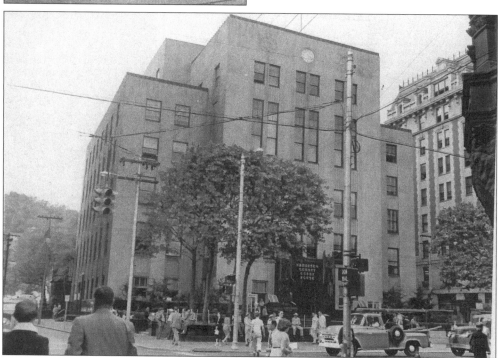

The courthouse that opened on West Main Street in 1932 and continues to serve the county is shown in this 1962 photograph. A new annex and correctional center were built in the late 1970s and replaced the old county jail behind the courthouse and the sheriff's residence, which fronted South Third Street.

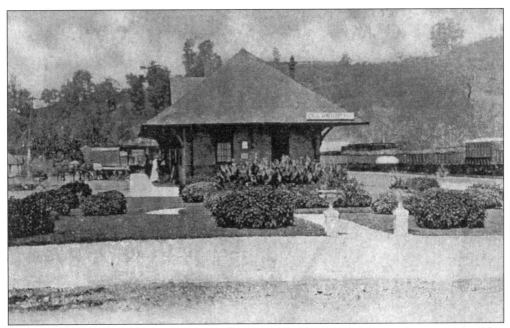

The Baltimore & Ohio Railroad depot in Clarksburg, located on Baltimore Avenue in the Glen Elk section, is shown here in the early twentieth century. It accommodated passengers until Amtrak service through Clarksburg ceased in the early 1980s. The photos on this page were taken from postcards. (Courtesy of Eugene Jaumot of Bridgeport.)

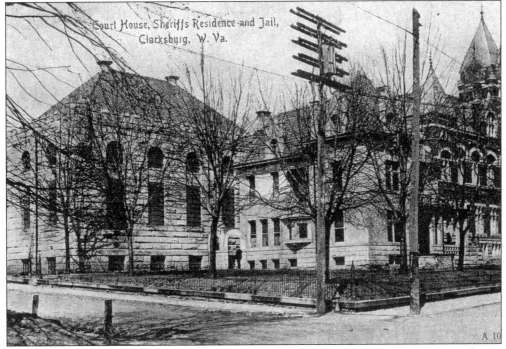

Taken in the late 1920s, this image shows the old Harrison County Jail and sheriff's residence, with the red brick courthouse—the county's second—in the background. The jail was replaced in the late 1970s by the Harrison County Correctional Center.

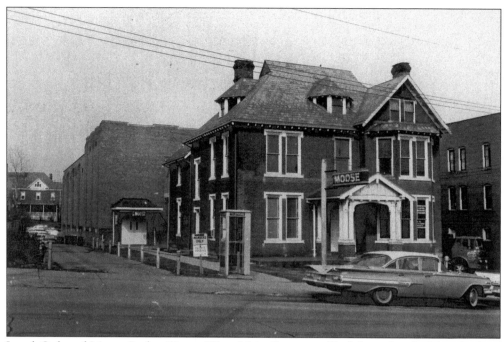

Loyal Order of Moose Lodge 52, on West Main Street in Clarksburg, has had hundreds of members over the years. The front "house" portion was torn down in the mid-1990s, but the lodge remains in the renovated structure in the rear.

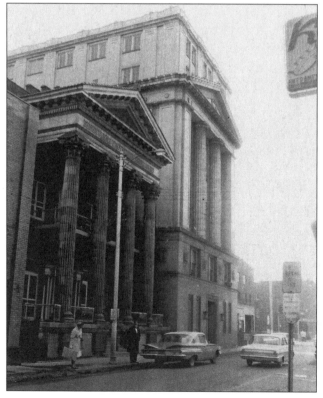

The pillared Benevolent Protective Order of Elks on West Pike Street—the taller building is the Masonic Temple—was home to Clarksburg Lodge 482 from 1911 until 1999. The local Elks lodge, which has also had many members, marked its 100th anniversary in 1999.

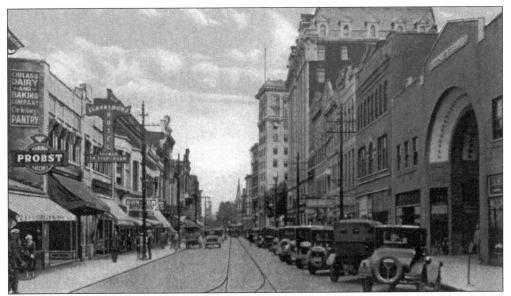

Parallel parking was apparently not an issue on West Main Street in the 1930s, as evidenced in this picture postcard. Visible are the Arcade Building, the Goff Building, and the Union National Bank on the right side of the street, and Probst Jewelers, Chicago Dairy & Baking Co., and Bon-Ton department store on the left, as well as other businesses. (Courtesy of Eugene Jaumot of Bridgeport.)

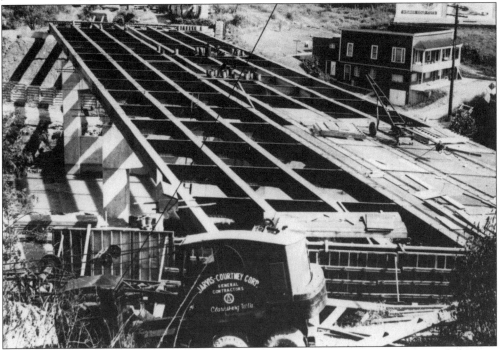

Construction on the Clarksburg Expressway (U.S. Route 50) began in 1956. This scene shows work in 1962 on the bridge that passes over Elk Creek, Baltimore Avenue, and Sycamore Street. The four-lane expressway was completed eastward toward Interstate 79 atop Bridgeport Hill by the late 1970s and westward beyond Limestone Junction. (Courtesy of Bob Nichols.)

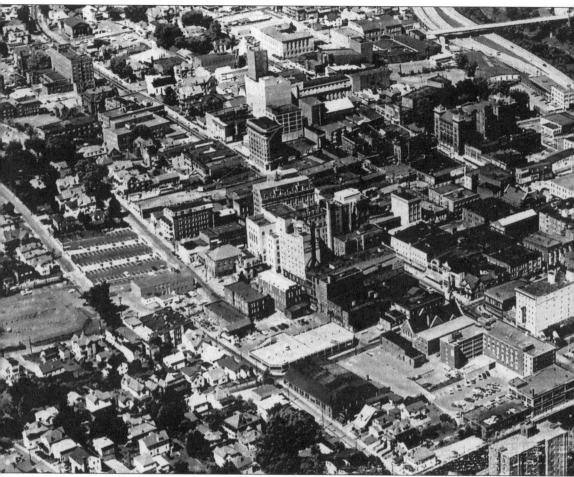

This aerial view of Clarksburg shows the central business district and surrounding areas. The completed Clarksburg Expressway and its ribbons of concrete have long provided motorists with a bypass around the city. Since this photograph was taken in 1972 by Edwin G. Propst, several

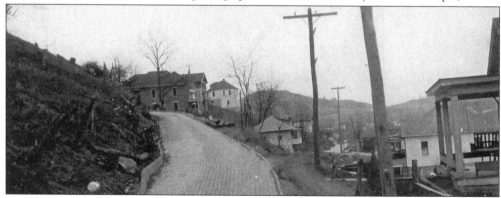

Milford Street, part of U.S. Route 19 in the western part of Clarksburg, was brick in the early 1920s. This photograph was taken looking north from a point near the intersection with Magnolia Avenue, which is barely visible between the utility poles. (Courtesy of Wayne Northey of Triple A Auto Club in Bridgeport.)

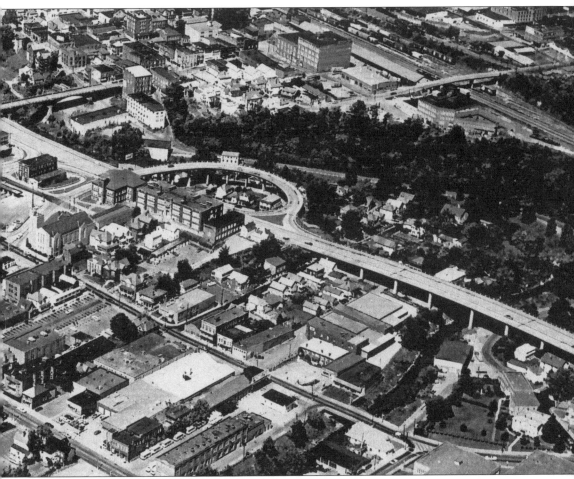

downtown buildings have been replaced by other structures or parking lots. Numerous businesses have since moved to shopping malls and centers, or have closed. (Courtesy of Joyce Propst.)

The portion of Milford Street (looking south) in the foreground had been bricked when this photograph was taken, but the section beyond was still dirt. The house in the 700 block, seen here, still stands today. (Courtesy of Wayne Northey.)

At one time the stately residence of General Nathan Goff, this building served for years as the Clarksburg Public Library. A new, modern Clarksburg-Harrison Public Library opened in 1975 on property just to the west. The mansion became well known as Waldomore and houses a number of resources that provide information on the history of Harrison County.

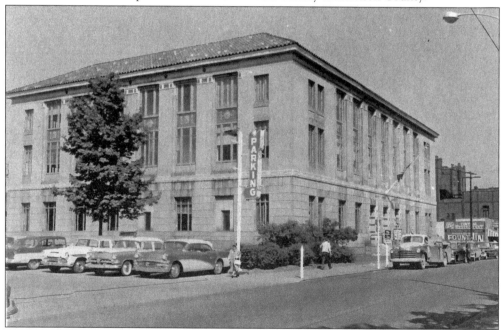

For years, Clarksburg's downtown post office served the city and close environs. The parking lot in the foreground, as well as a gasoline station and supermarket, were replaced in later years by a parking facility for postal employees. This photograph was taken in the late 1950s.

The Stonewall Jackson Hotel, a 12-story structure that was named for Clarksburg's most famous native, opened in 1929. No longer a hotel, it now houses a major law practice and some corporate offices. (Courtesy of Eugene Jaumot of Bridgeport.)

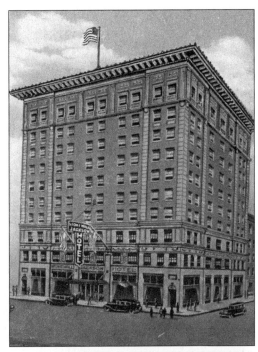

Until the early 1960s, Clarksburg City Hall was a two-story pink building on West Main Street between the Hope Gas Co. building and the Firestone Tire store. City hall then relocated to West Pike and Third Streets where it stayed until 1999, when city offices were moved to a brand-new building at West Main and Third Streets, just a block away.

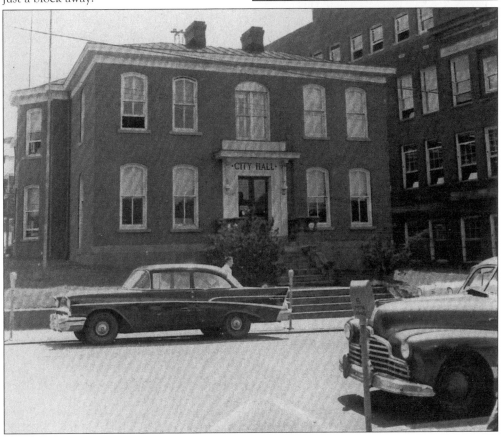

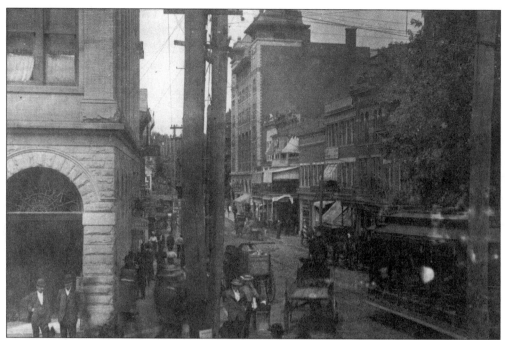

The 300 block of West Pike Street was once a bustling place around the turn of the twentieth century. The Trust Building is shown in the left foreground, and the Waldo Hotel is in the background on the right side of street. A number of horse-drawn buggies surround one of the many streetcars that traveled through the city. (Courtesy of Bob Nichols.)

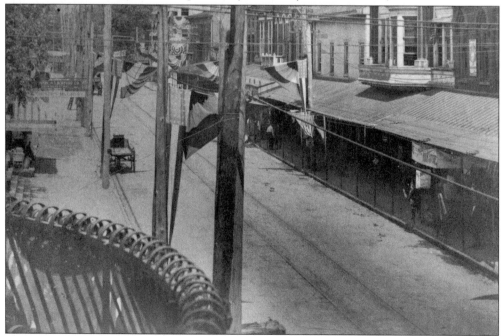

This scene taken from the old Traders Hotel—a portion of its second-floor balcony railing can be seen in the bottom left corner—shows Main Street in the late nineteenth century. Note the sidewalk in front of the stores that is enclosed by a 6-foot-high screen or fence.

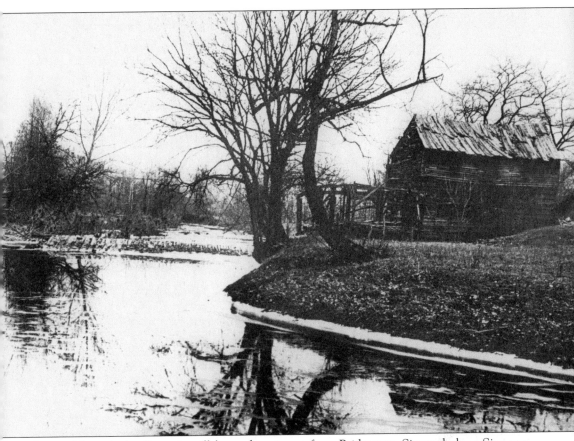

Pictured here is the first gristmill located upstream from Bridgeport. Situated along Simpson Creek, it was built on a site that is near the current intersection of WV Route 76 (Flemington Road) and the Oral Lake Road. (Courtesy of Bob Nichols.)

Found along the southbound lane of U.S. Route 19 in Enterprise, northern Harrison County, this historical marker describes the graves of Revolutionary War soldiers Jacob Bigler and Elisha Griffith, who settled in Harrison County after moving from Maryland following the war.

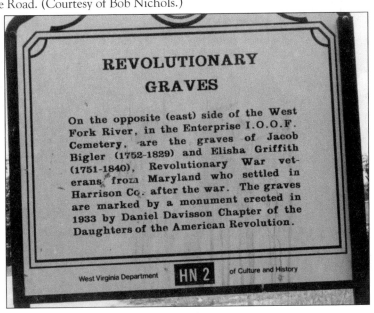

REVOLUTIONARY GRAVES

On the opposite (east) side of the West Fork River, in the Enterprise I.O.O.F. Cemetery, are the graves of Jacob Bigler (1752-1829) and Elisha Griffith (1751-1840), Revolutionary War veterans from Maryland who settled in Harrison Co. after the war. The graves are marked by a monument erected in 1933 by Daniel Davisson Chapter of the Daughters of the American Revolution.

West Virginia Department **HN 2** of Culture and History

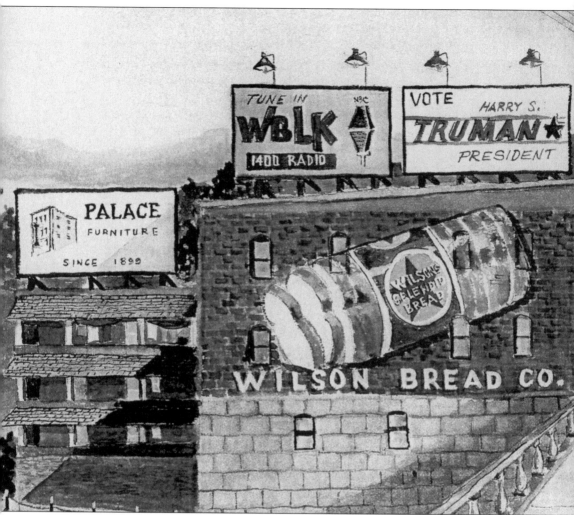

Robert Cotter captured the mood of the Glen Elk section of Clarksburg in this reproduction. The scene shows Glen Elk from the southern end of the Fourth Street Bridge. Note the campaign sign for Harry Truman on the side of the building, just above the Wilson Bread sign. Many such signs were painted on the sides of structures in that section of town. For years Glen

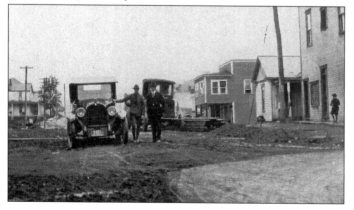

Neighbors chat beside their automobiles in the Industrial section of Clarksburg. These people stand at the intersection of Broadway with East Main Street when both were no more than dirt tracks. (Courtesy of Wayne Northey.)

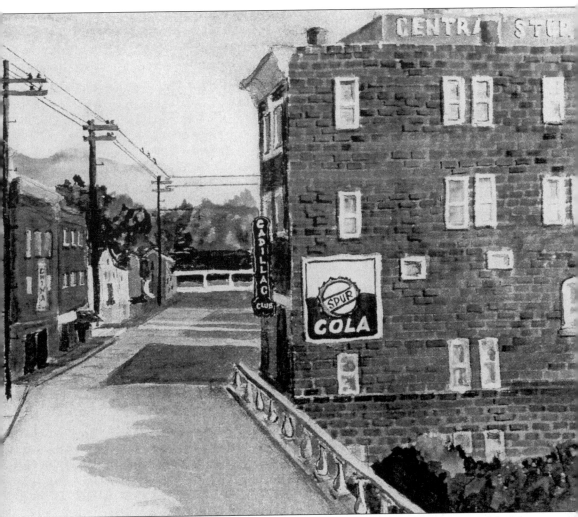

Elk was the site of numerous warehouses, as well as other businesses, including several hotels and grocery stores. The Baltimore & Ohio Railroad carried passengers and freight traffic east and west through Clarksburg and had its depot along Baltimore Avenue. A neighborhood renewal program is currently underway in Glen Elk. (Courtesy of Virgil LaRosa.)

Yet another historical marker, this one posted along Veterans Drive (WV Route 98) in Clarksburg, refers to the noted oak mounds that were located a short distance away. The description summarized on the sign tells the story best.

OAK MOUNDS

Directly to the east are two earthen, domed burial mounds. The larger mound is some sixty feet in diameter and twelve feet high. Excavations in 1969 revealed flint tools, pottery sherds and skeletal remains of two individuals. Site dates to about 100 BC, late Early Woodland Period.

Once the site of hundreds of art exhibits and many popular dramatic productions, the Clarksburg Art Center was located at 207 Marshall Street in the city's East End. That building and those that fronted East Main Street were razed in the late 1980s. It is now the site of a Hardee's fast-food restaurant.

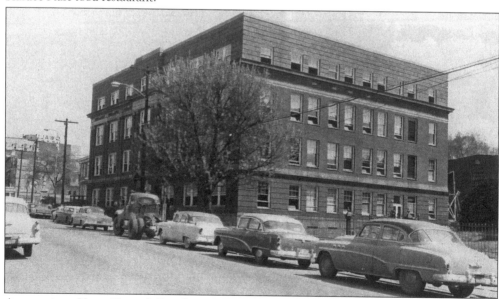

At one time, Hope Natural Gas Co. operations were directed from this building in the 400 block of West Main Street in Clarksburg. Following considerable expansion, the larger complex housed Consolidated Gas Supply Corp., later Consolidated Natural Gas (CNG) Transmission, Inc., and today, Dominion Resources. The picture was taken in the mid- to late-1950s.

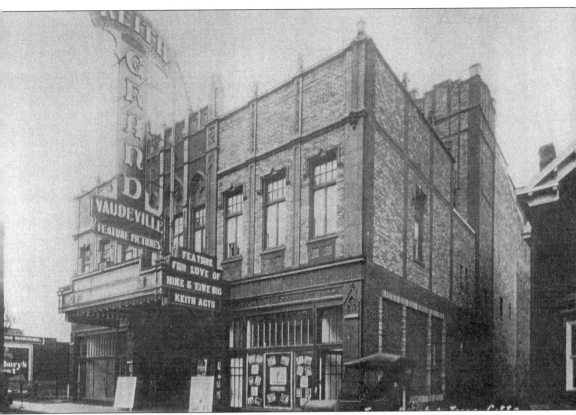

For Love of Mike was the feature playing at the Keith Grand Theater when this photo was taken shortly after 1900. As the marquee indicates, five other "Big Keith" acts were also featured. R.C. Holmboe was the architect of the building and Holmbanks Co. was the contractor. It was faced with brick and terra cotta, furnished by Thornton Fire Brick Co. of Clarksburg. It later became the Robinson Grand Theater, and later still, the Rose Garden Theatre. (Courtesy of Philip's Restaurant, Clarksburg.)

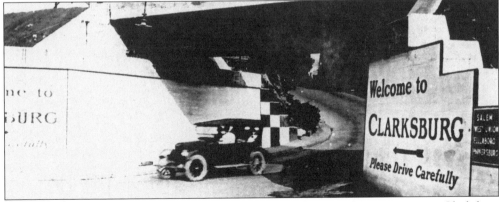

This friendly sign, pictured here in 1926, greeted motorists arriving in Clarksburg from Shinnston, Fairmont, and other points north on U.S. Route 19. The white concrete underpass carried traffic below railroad tracks in the Adamston section of Clarksburg. This intersection was best known by area residents as Limestone Junction. (Courtesy of Mary Thrash of Clarksburg.)

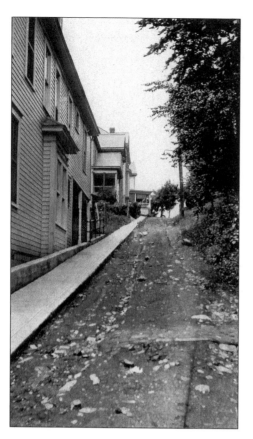

Many houses built in Clarksburg in the nineteenth and twentieth centuries were constructed on hillsides, such as these along Hickman Street. A boarded sidewalk flanked the dirt- and rock-surfaced street until brick was laid several years later. Imagine winter driving then! (Courtesy of Wayne Northey.)

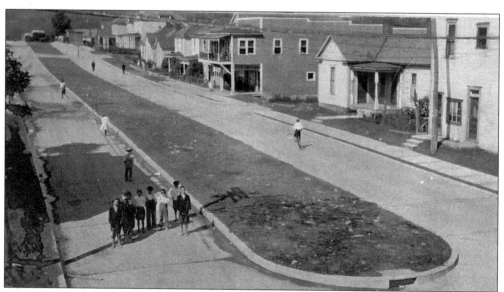

One of few streets in all of Clarksburg with a grass median, this end of Broadway Avenue headed south from East Main Street in the Industrial section of Clarksburg. This group of neighbors stands in the northbound lane just after the street was paved in the late 1920s. (Courtesy of Mary Thrash of Clarksburg.)

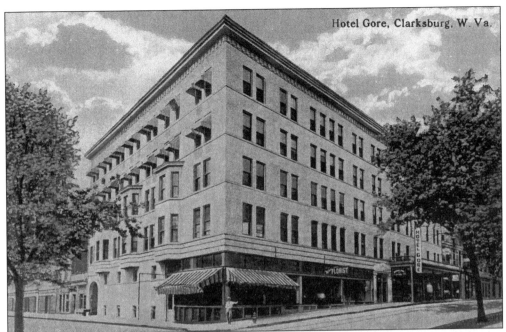

Hotel Gore, at the corner of West Pike and Second Streets in downtown Clarksburg, was one of the foremost hotels in the city. The building once housed a florist shop and other businesses. The appearance of the building, no longer a hotel, has been modified somewhat over the years and now contains apartments on the side that faces Second Street. (Courtesy of Eugene Jaumot of Bridgeport.)

In Clarksburg's Broad Oaks section, Lynn Street (in the upper right) was paved, but Quincy Street (at left) was still dirt in the 1920s. Pinnickinnick Hill is silhouetted in the left background. (Courtesy of Wayne Northey.)

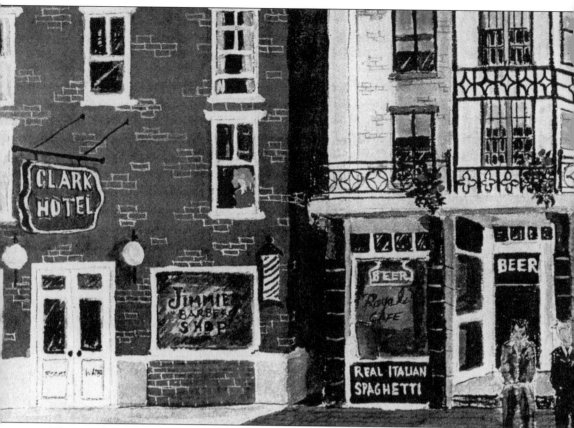

The Royal Cafe, which faced Clark Street at the corner of North Fourth Street in Clarksburg's Glen Elk section, was one of the more uniquely designed building exteriors in the city, as shown in this artistic work by Robert Cotter of Bridgeport. Located adjacent to the Royal Cafe was the

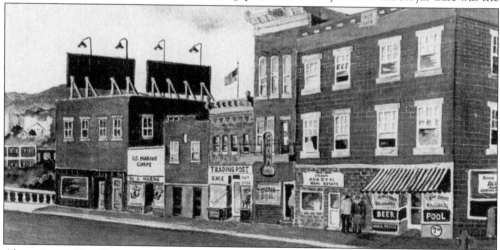

Above is another illustration by Bridgeport artist Robert Cotter that shows a section of North Fourth Street between Clark Street and the Fourth Street Bridge. Storefronts included are Fourth Street Billiards, Frank Angotti Real Estate, the China Doll, the Trading Post, the U.S. Marine Corps recruiting station, and others. (Courtesy of Virgil LaRosa.)

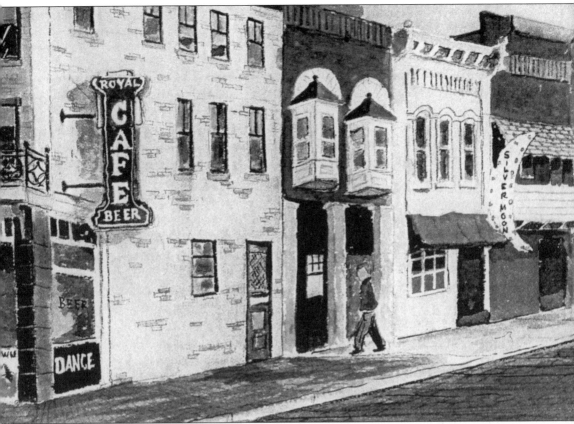

Clark Hotel. Glen Elk was the location of quite a number of hotels in the late 1800s and early 1900s. (Courtesy of Virgil LaRosa.)

Curving along Elk Creek was the dirt-surfaced Sandy Boulevard in Clarksburg, seen in this photo taken around 1920—judging by the vehicle seen traveling west. (Courtesy of Wayne Northey.)

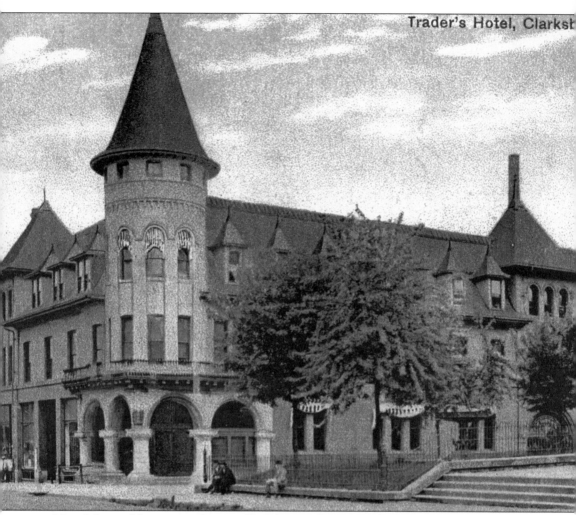

Noted for its Victorian style was Clarksburg's elegant Trader's Hotel, which was situated downtown on West Main Street at the corner of South Third Street. In the right foreground of this image are the steps of the Harrison County Courthouse. The hotel occupied much of the block but was destroyed by one of the city's most spectacular fires on January 20, 1911. (Courtesy of Rod Rogers.)

Yes, motorists did it back then, too. One vehicle passes another, headed south in the 300 block of Milford Street, in this 1926 photo. The Edmund Stealey home was once located across the street from the houses on the right. (Courtesy of Mary Thrash of Clarksburg.)

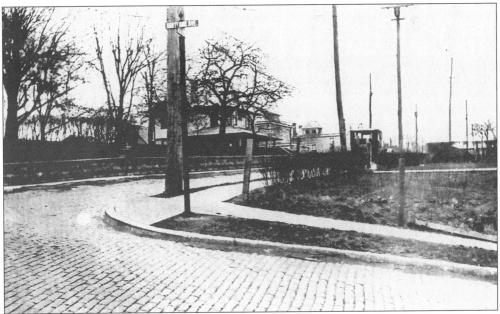

This 1926 photograph shows the intersection of Milford Street and Hartland Avenue. The house in the background still stands today, but at least three houses that are now on the opposite side of the street had not yet been built. (Courtesy of Mary Thrash of Clarksburg.)

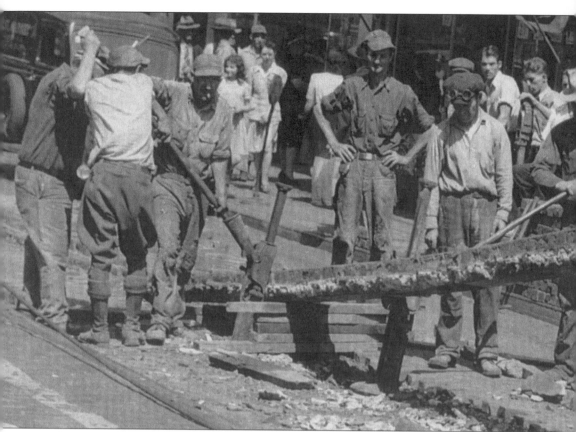

A portion of streetcar track was removed by these workers on South Fourth Street in downtown Clarksburg in the late 1940s. There were few if any vacant stores in the city's central business district at the time. Those visible are Friedlander's women's store, Fountain Cut Rate, the Style

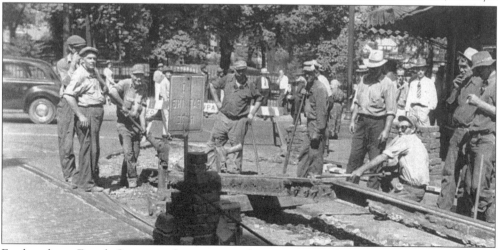

Further down Fourth Street, work to remove the streetcar tracks was also in progress. In the background, trees hide the Clarksburg Public Library, now Waldomore Mansion. At right can be seen Candyland, a classic landmark in downtown Clarksburg and a favorite stopping place of many. (Courtesy of the Harrison County Historical Society.)

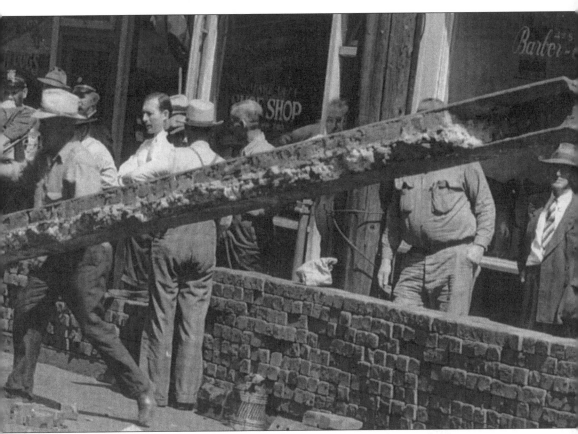

Shop, the Fourth Street Market, Square Deal Shoe Shop, a barber shop, and a few restaurants. Note the brick wall that separates the sidewalk from the street. (Courtesy of the Harrison County Historical Society.)

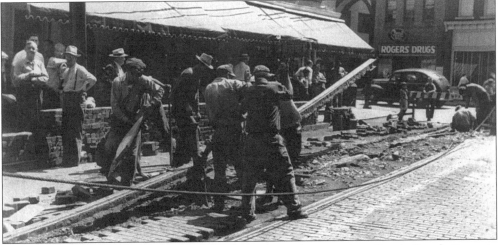

Completing the set of photographs of the streetcar track removal on South Fourth Street in downtown Clarksburg, this view shows Roger's Drugs and the Arcade Building in the background. The building at left with the awnings would later become Friedlander's women's store. (Courtesy of the Harrison County Historical Society.)

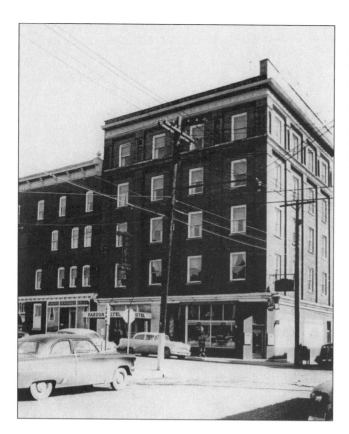

Parson Hotel, one of numerous former lodging places in Clarksburg's Glen Elk section, still stands at the corner of Clark and North Fifth Streets but is no longer a hotel. Philip's Restaurant, owned by Phil Podesta, is located on the ground floor. This picture was taken in the mid-1950s. (Courtesy of Phil Podesta.)

Clarksburg features many hilly areas within its corporate boundaries. One of the highest points in the city is Wilson Street, where a number of houses are seen. This photo was believed to have been taken in the 1930s or 1940s. (Courtesy of Wayne Northey, AAA auto club, Bridgeport.)

Four

THE WAY WE WERE

The memories that are vivid in the minds of some Harrison Countians are somewhat remote in the minds of others. From boarded sidewalks to musical "combos," a few of the things that have been cherished and enjoyed by residents of Harrison County are captured here in photographs. The things we used to do, the places we used to go, the customs of yesterday that remain so fond to us—the following pages will hopefully remind many of the way we once were.

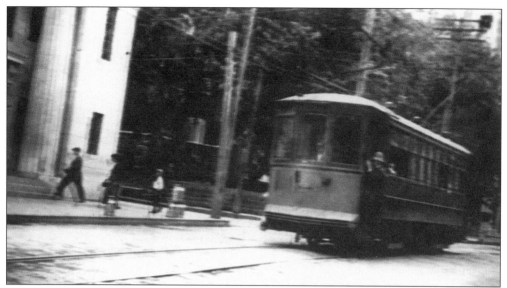

Some of the older residents of Harrison County and Clarksburg will remember the streetcars that ran through the city and some sections of the county. This streetcar moves along West Main Street at its intersection with South Third Street downtown. At left is the entrance to the Union National Bank, now Bank One. (Courtesy of Bob Nichols.)

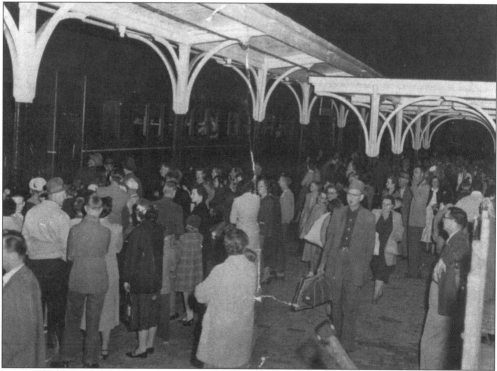

This scene at the Baltimore & Ohio Railroad station in Glen Elk occurred just after the United States entered World War II after the Japanese attack on Pearl Harbor on December 7, 1941. Family members bid loved ones goodbye as they prepare to depart to join the war effort. (Courtesy of the late Margaret Carr.)

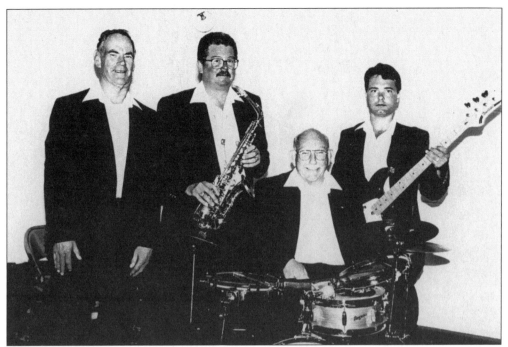

Good music of all kinds continues to fill the air of Harrison County today. This easy listening quartet is shown in more recent days as they performed in the area. From left to right are lead singer Wayne Knotts, saxophonist John Morgan, drummer Bill Kirkpatrick, and bass guitarist Edwin Propst Jr. (Courtesy of Philip's Restaurant, Clarksburg.)

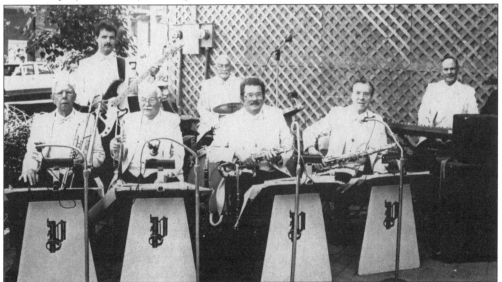

Some of the members of the quartet in the top photograph were also members of "The Pastels," a well-known and much-requested musical "combo" of recent years (in bottom photo). Shown here are Bob Swain on trombone, Ed Propst (standing) on bass guitar, Don Campbell on trumpet, Bill Kirkpatrick (background) on drums, John Morgan on alto saxophone, Jim Jenkins on tenor saxophone, and Wayne Knotts on keyboard. (Courtesy of Philip's Restaurant, Clarksburg.)

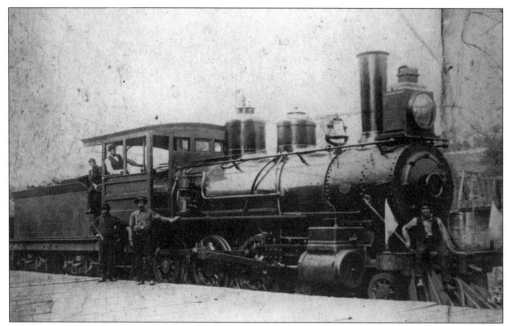

What could be more fun in days of old for the young and the "young at heart" than to watch a freight train moving through town? This early steam locomotive was photographed with railroad workers around 1900. (Courtesy of Bob Nichols.)

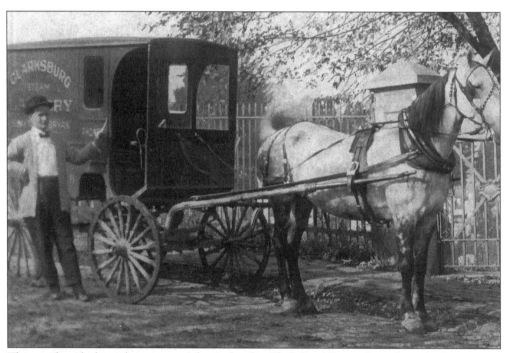

This unidentified gentleman was a driver for the Clarksburg Steam Laundry, which was once located at 100 West Pike Street in the city. The company made its deliveries and pickups by horse and buggy. This photo is believed to have been taken in the early twentieth century. (Courtesy of Harold V. Tate of Clarksburg.)

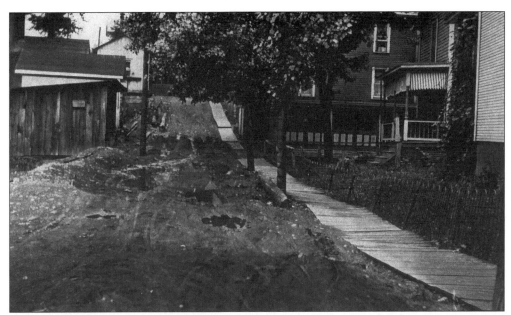

Boarded sidewalks were commonplace in the early 1900s, as evident in this Clarksburg neighborhood. Before the 1920s and 1930s, many of the city's streets were still dirt-surfaced and could become rather muddy after a rainstorm. (Courtesy of Wayne Northey.)

There was nothing more enjoyable for these kids than going fishing with Lloyd "Buck" Mowrey (reclined on grass), a Wolf Summit barber in the 1930s, 1940s, and 1950s. He would drive his 1924 Model T Ford to the fishin' holes in the mid-1940s. Pictured from left to right are (front row) Eugene Calvert, Jim Davis, Earl Hitt, Eugene Cox, Dick Winans, and Bob Cox; (back row) unidentified, Dick Davis, Ed Winans, unidentified, Leon Cox, Lloyd Murphy, and unidentified. Mowrey was the father of well-known Harrison County educator Corma Mowrey. (Courtesy of James A. Murphy of Bristol.)

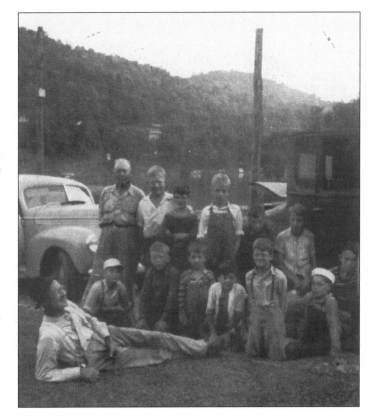

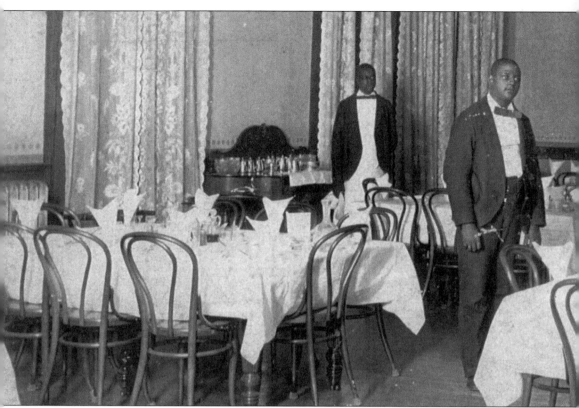

This is a view of the Traders Hotel dining hall and some of its personnel. According to Dorothy Davis's book *History of Harrison County*, the hotel opened in September 1895 with W.T. Barber as lessee. Ownership of the hotel changed several times. In addition to the hotel, the Traders

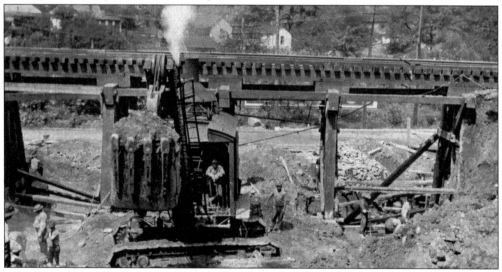

A work crew erects one of several railroad trestle bridges in Clarksburg, this one in the western section of the city near the site of what is now the Clarksburg Expressway. Some more daring souls would walk across the trestles—when a train wasn't approaching! (Courtesy of Wayne Northey.)

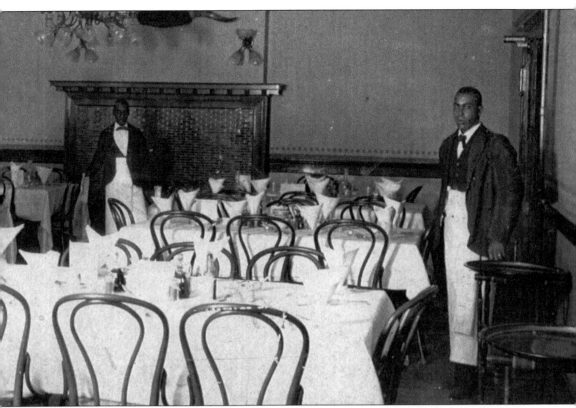

Building housed a bank, eight stores, three lodges, an opera house, and a number of offices. The Victorian-style building was destroyed by fire on January 20, 1911. (Courtesy of Rod Rogers .)

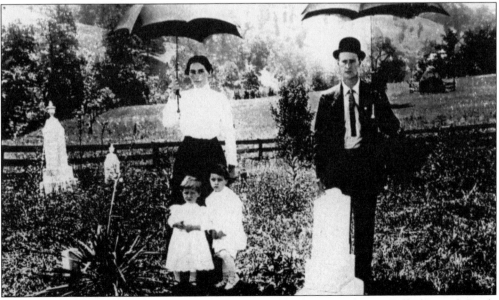

Standing with umbrellas on Memorial Day 1913 are Charles W. and Amy Belle (Carter) Sandy at the grave site of their daughter Irene near Sardis. They are shown with their sons, C. Willard and Carter E. Sandy. (Courtesy of Charles Sandy's grandson, Ron Sandy of Clarksburg.)

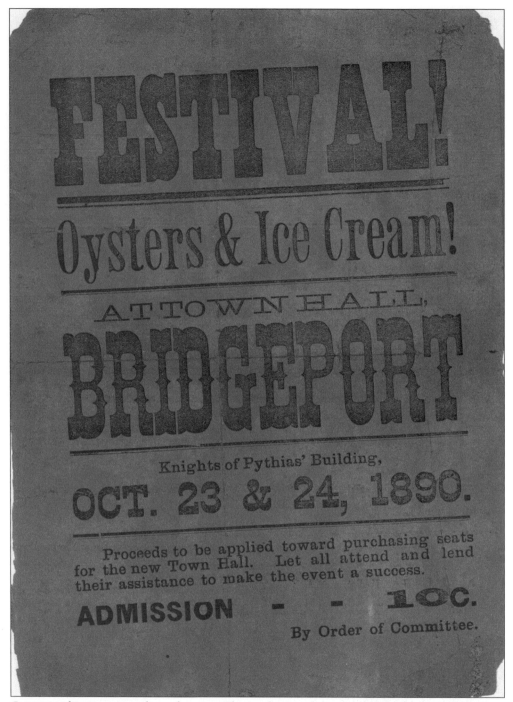

Oysters and ice cream—what a favorite! That's what was being served at a festival at the town hall in Bridgeport in 1890, as shown on this poster. Admission was just one thin dime. Such posters advertised many events of the late nineteenth and early twentieth centuries in Harrison County. (Courtesy of the Harrison County Historical Society.)

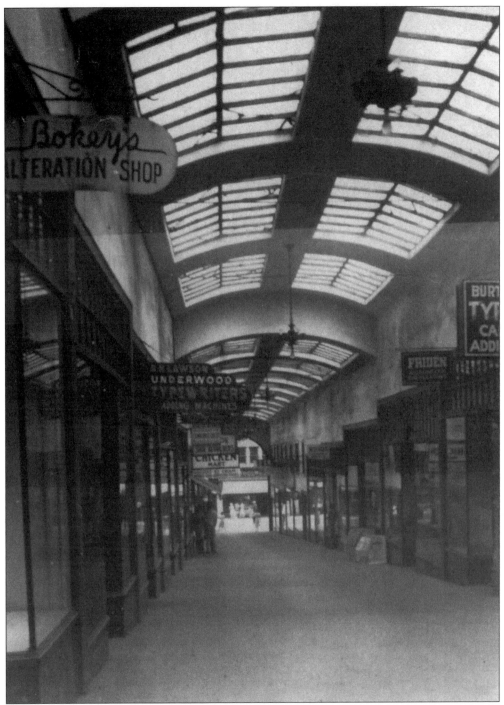

The Arcade Building was quite an interesting place to shop in downtown Clarksburg—maybe thought of as the 1940s and 1950s answer to today's sheltered shopping malls. Businesses in the Arcade Building included Bokey's Alteration Shop, Burton's Typewriters, R.M. Lawson Typewriters, Drexal's Music Store, and numerous others. The Arcade Building was destroyed by fire in 1957. (Courtesy of George Kovach of Clarksburg.)

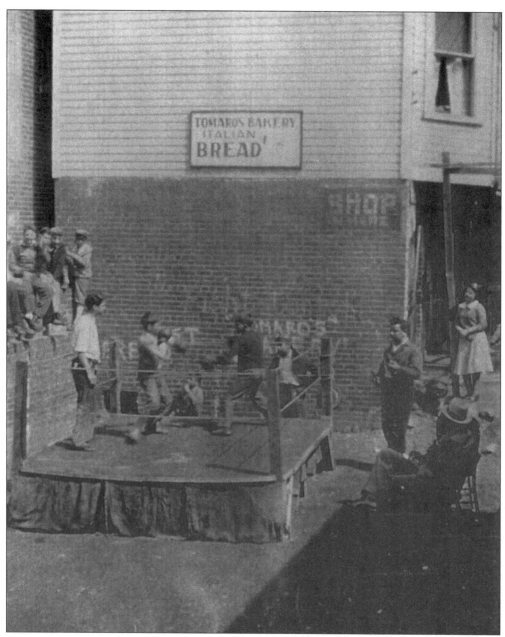

Boxing matches between youngsters took place in this small elevated ring on North Fourth Street in Glen Elk many years ago. The matches would attract a number of people each time they were staged. The building housed Tomaro's Bakery, which continues to this day to prepare delicious Italian bread and pepperoni rolls. (Courtesy of Philip's Restaurant, Clarksburg.)

Five

SPECIAL OCCASIONS AND
MEMORABLE EVENTS

Harrison County has been privileged in past years to have been visited by a number of nationally known individuals. Most recently, President Bill Clinton visited on May 22, 1997 for a town hall meeting on education. In the past, the county was visited by President Harry S. Truman during his 1948 "whistle stop" in Clarksburg while campaigning for his first full term in the White House. Also, John F. Kennedy was in Clarksburg in early 1960 while seeking the Democrat nomination for president prior to the May primary, as was his younger brother, Robert, who was in town the same year for the same reason. Ted, however, is the only one of the three to be captured in a photo while visiting the county. In August 1924, Clarksburg native John W. Davis came home to deliver his acceptance speech as the Democrat nominee for President of the United States. He was met by one of the largest crowds ever to assemble in Harrison County or Clarksburg. The latter part of this chapter features several photos and items related to this event.

Conversely, the county has had its share of tragedies that include the Shinnston tornado and the murders of two women and three children by Bluebeard killer Harry Powers, the latter of which was not chosen for use in this work due to its hideous nature. Some of the happenings will be quickly recalled, perhaps others not so quickly.

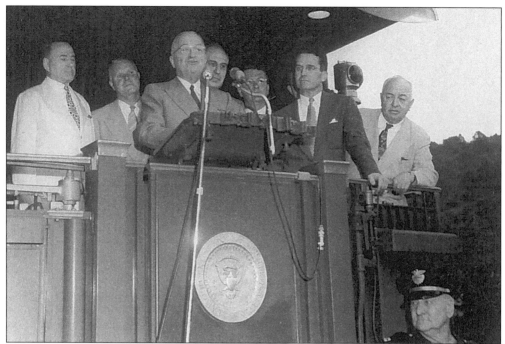

The 33rd president of the United States, Harry S. Truman, made a whistle stop in Clarksburg while campaigning in 1948 for his first full term as chief executive. He is shown here, surrounded by local, state, and national dignitaries and speaking to the large crowd that had assembled. (Photograph by the late Charles Henry; courtesy of his widow, Betty Henry of Clarksburg.)

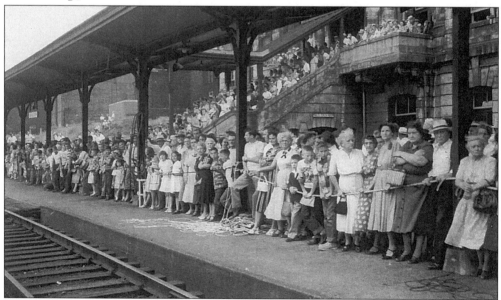

Throngs of admirers were present at the Baltimore & Ohio Railroad station in Glen Elk, preparing to greet President Harry S. Truman during his whistle stop in 1948. Thousands of people were present for his appearance. (Photograph by the late Charles Henry; courtesy of his widow, Betty Henry of Clarksburg.)

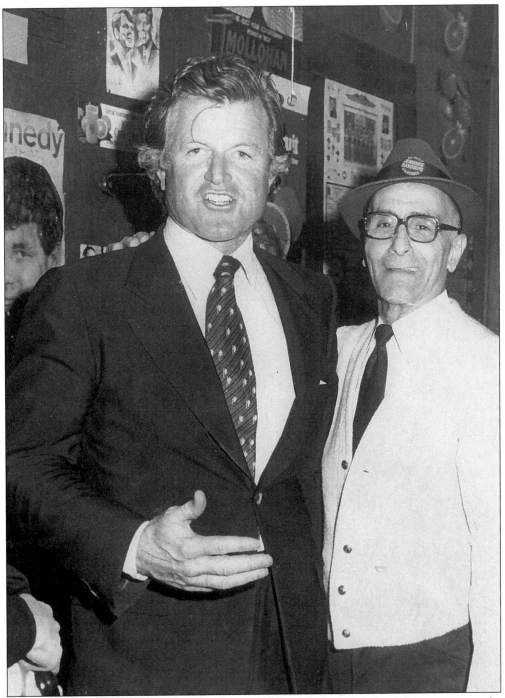

Senator Edward "Ted" Kennedy of Massachusetts visited Clarksburg in 1968 to campaign for his brother Robert, Democrat front-runner for president that year until his tragic assassination in June. Ted is shown here with longtime Shinnston area resident John Tate, the owner of Tate's Fruit Market. Kennedy continues to serve in the U.S. Senate. (Courtesy of John Tate.)

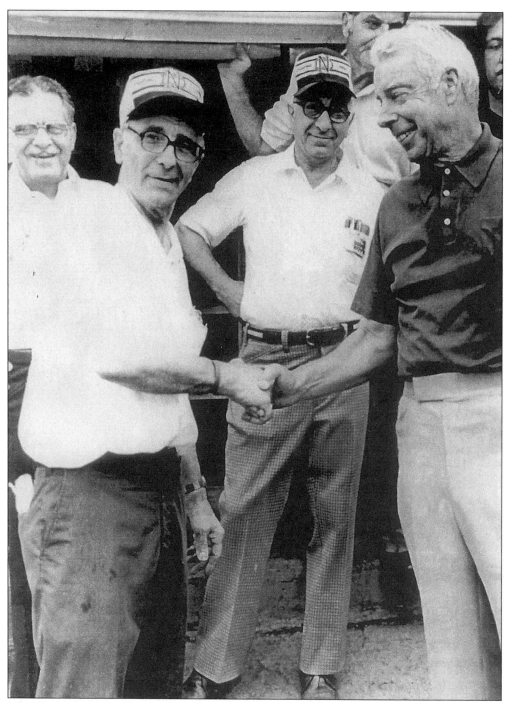

John Tate, a longtime Harrison County resident, is shown greeting Major League Baseball Hall-of-Famer Joe DiMaggio when the latter paid a visit to the city for the first West Virginia Italian Heritage Festival in 1979. John's brothers, Louis and Sam Tate, stand behind him. (Courtesy of John Tate.)

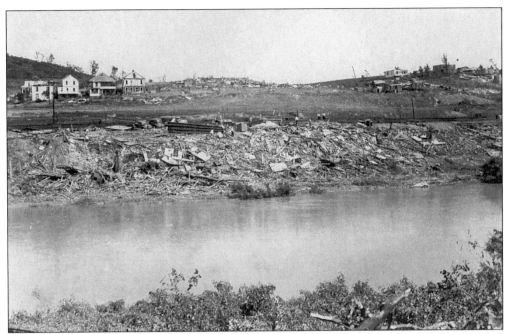

Utter devastation was the result of a tornado that struck much of North Central West Virginia on June 23, 1944. The Shinnston area was especially hard hit, thus the name "the Shinnston Tornado." This is a view of demolished homes along the West Fork River in Shinnston. Seventy-two Harrison Countians lost their lives in the storm, and 222 were injured. (Courtesy of Jean Reese of Clarksburg.)

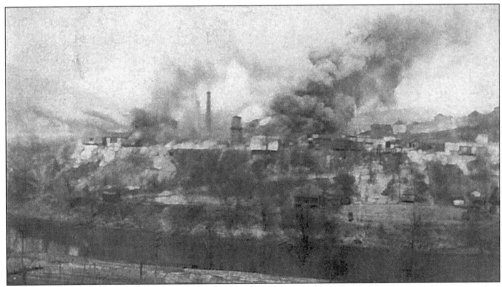

A major blaze in Clarksburg that is perhaps not as quickly recalled as others was one that destroyed the Lafayette Window Glass factory on March 25, 1919. The plant was located at a site later occupied by the Rolland Division of Fourco Glass in North View. (Courtesy of Bernice Houillet of Clarksburg.)

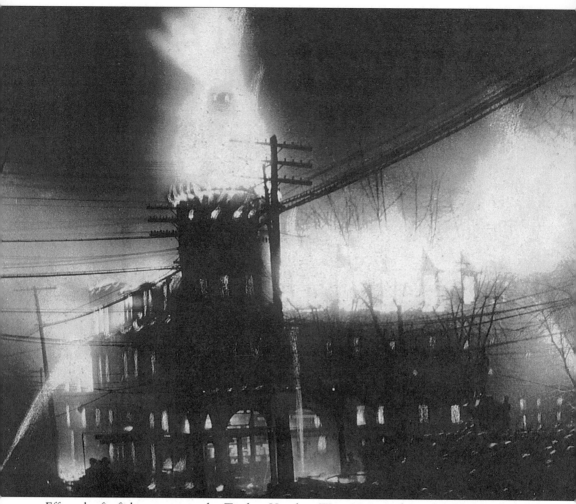

Efforts by firefighters to save the Traders Hotel at West Main and South Third Streets and virtually the entire block proved futile on the night of January 20, 1911. The following day showed the tremendous amount of damage resulting from the fire that destroyed the Victorian-style Traders Building that had once held an opera house, a bank, and a number of stores. (Courtesy of Rod Rogers.)

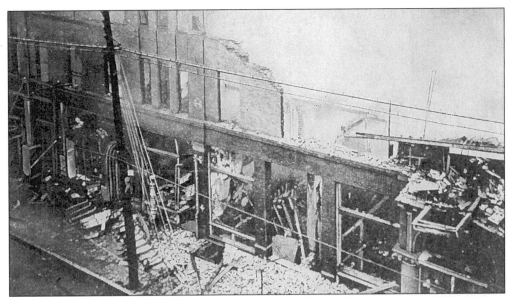

This is another view of the destruction to the Traders Hotel in downtown Clarksburg resulting from the spectacular fire of January 20, 1911. Nothing but ashes and rubble remained.

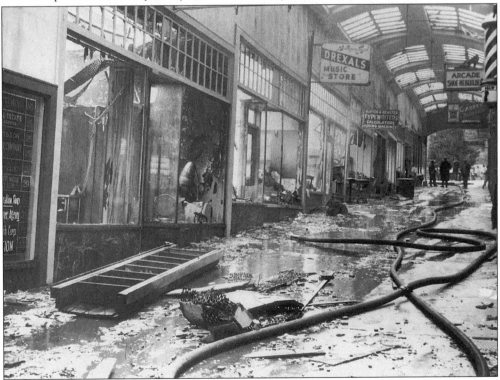

The popular Arcade Building on West Main Street in downtown Clarksburg did not fare much better in the fire that destroyed it in October 1957. Only fire hoses, ladders, debris, and water can be found on the former walkway, which some daring teenagers had previously attempted to navigate in their motor vehicles when they thought nobody was watching. (Courtesy of Bob Nichols.)

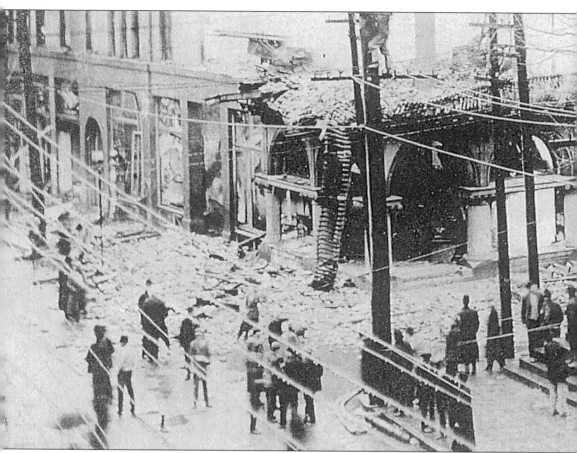

Onlookers gaze in disbelief at the charred remains of the Traders Hotel at West Main and South Third Streets after the January 20, 1911 blaze that leveled nearly the entire downtown

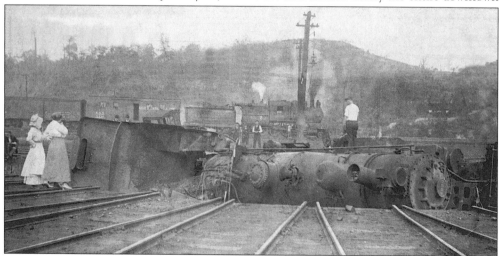

Little if anything has been documented at length about this train wreck somewhere along the Baltimore & Ohio Railroad line, which ran east to west through Bridgeport, Clarksburg, Wolf Summit, and Salem. (Courtesy of Bob Nichols.)

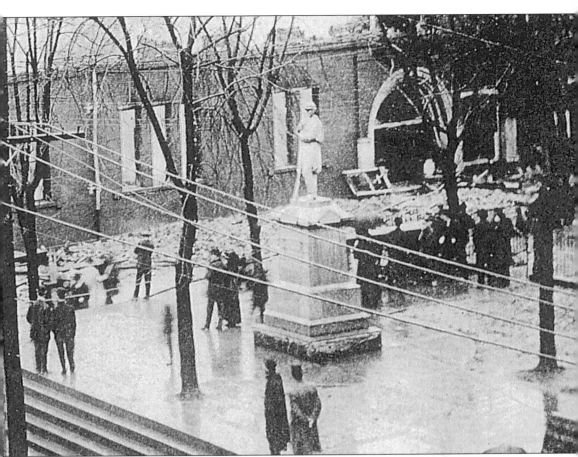

block. In the foreground is the Harrison County Courthouse plaza. The site was later occupied by the Union National Bank and the Prunty Building. (Courtesy of Rod Rogers.)

Folks who were in downtown Clarksburg on this day some time in the early 1960s had the opportunity to see the mast from the USS *West Virginia*, which was briefly placed on display. The USS *West Virginia* was one of the vessels that was severely damaged in the Japanese attack on Pearl Harbor in 1941. The mast now stands at Oglebay Plaza on the campus of West Virginia University in Morgantown. (Courtesy of Bob Nichols.)

A gala celebration was held on Saturday evening, March 15, 1930, to mark the opening of the new Stonewall Jackson Hotel, a 12-story building that was located on South Third Street in

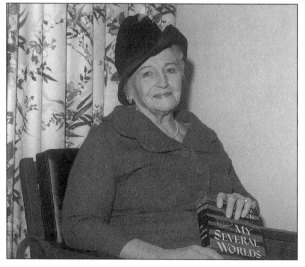

Pearl Buck, beloved author and native of West Virginia, stopped in Clarksburg on November 10, 1970, following the release of her book, My Several Worlds. The native of Hillsboro is perhaps best known for her work, The Good Earth. (Courtesy of Mrs. Charles Henry.)

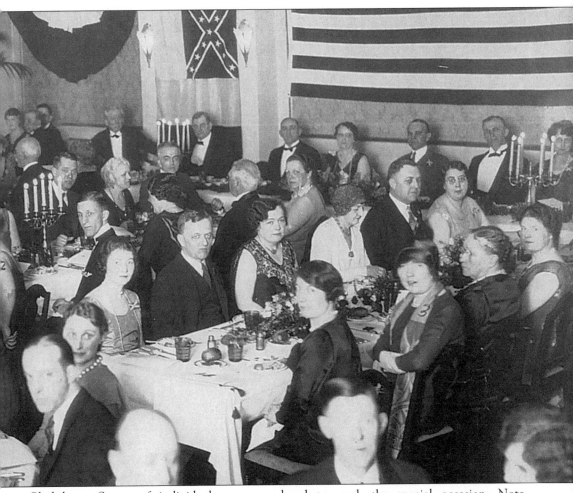

Clarksburg. Scores of individuals were on hand to mark the special occasion. Note the American and Confederate flags on the back wall. (Courtesy of Rod Rogers.)

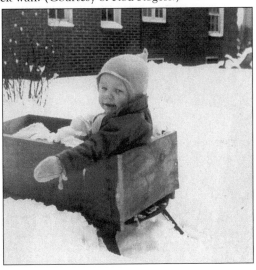

This little guy seems to have enjoyed a ride in the box-sled seen here just after a 1948 snowfall in a neighborhood in Clarksburg's Hartland section. The storm was not as heavy as one that dumped 37 inches or more on the area on Thanksgiving weekend, 1950.

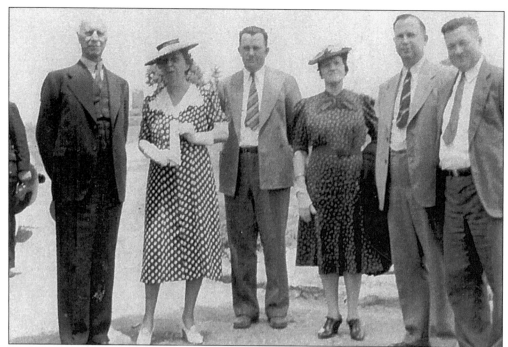

Michael Benedum and his wife are shown here with four other individuals in 1939 for the grand opening of a new portion of the Bridgeport Cemetery. Standing in front of the cemetery chapel are, from left to right, Michael L. Benedum, his sister Miss Sophie Benedum, F.C. Burris, Mrs. Benedum, Dr. Carl Chandler, and Bridgeport Mayor Joe Deegan. (Courtesy of Alice Deegan Ulch of Tucker County.)

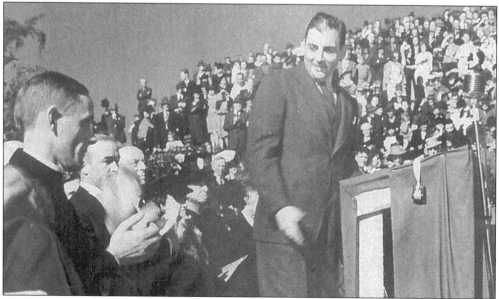

Bridgeport Mayor Joe Deegan stands at the podium during ceremonies for the laying of the cornerstone for a new section of the Bridgeport Cemetery on October 13, 1940. Seated behind him, third from left, is Michael L. Benedum, who donated a considerable sum of money for the cemetery addition. (Courtesy of Alice Deegan Ulch of Tucker County.)

CLARKSBURG

THE BIRTHPLACE OF

JOHN W. DAVIS

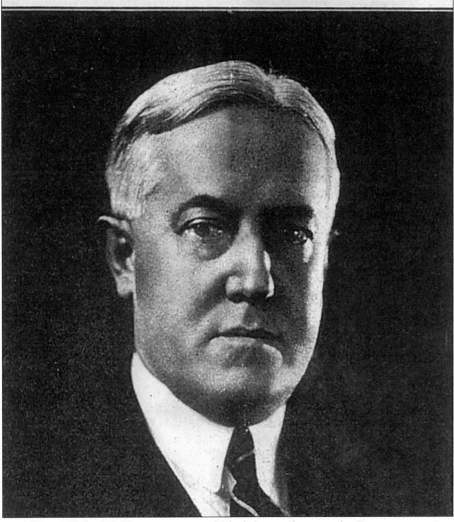

This is a photo of John W. Davis, a native of Clarksburg, who won the Democrat nomination for President of the United States in 1924. This photograph was taken from the official program for Notification Day Exercises held on August 11, 1924, when Davis gave his acceptance speech in the Goff Plaza section of town. (Courtesy of Rod Rogers.)

JOHN W. DAVIS

Born, Clarksburg, W. Va., April 13, 1873.

Son of John J. and Anna (Kennedy) Davis.

Graduated from Washington and Lee University, 1892, and later received honorary degrees from Washington and Lee, University of West Virginia, University of Birmingham, England; University of Glasgow, Union University, New York University, Yale and Princeton.

Married Julia T. McDonald, June 30, 1899, who died August 17, 1900; married Ellen G. Bassel, January 2, 1912.

Taught school, West Virginia, 1893.

Assistant professor of law, Washington and Lee University, 1896-1897.

Practiced law at Clarksburg, 1897-1913.

Majority floor leader West Virginia House of Delegates, 1899.

Democratic county chairman, (Harrison county, W. Va.,) 1900.

Delegate to Democratic National Convention 1904.

President of West Virginia Bar Association, 1906.

Delegate Democratic National Convention, 1908.

Member Democratic State (W. Va.) Executive committee, 1908.

Elected twice to Congress from the First district of West Virginia, 1911-1913.

Resigned from Congress to become Solicitor-General of the United States, August 30, 1913; Solicitor-General until 1918.

Counselor, American Red Cross, 1913-1918.

Elected trustee, Central Presbyterian church, Clarksburg, 1916.

Appointed member American High Commission on treatment and exchange of war prisoners, 1918.

Ambassador to Great Britain, 1918-1921.

President of the American Bar Association, 1922.

Member, Phi Kappa Psi and Phi Beta Kappa fraternities, a thirty-second degree Mason, and a life member of Clarksburg lodge of Elks.

Shown here are several facts about Clarksburg native John W. Davis, the Democrats' nominee for president in 1924. Also displaying the seal of the City of Clarksburg, this page is from an official program for Notification Day Exercises. (Courtesy of Rod Rogers.)

Notification Day Exercises

Goff Plaza
Clarksburg, West Virginia

Monday, August 11th, 1924

CLEMENT L. SHAVER
Chairman Democratic National Committee
Presiding Officer

"Star Spangled Banner" - - - Clarksburg Bands

Invocation - - - - Rev. Carroll Anderson Engle
Minister Central Presbyterian Church

Notification - - - Senator Thomas J. Walsh
Chairman Presidential Notification Committee

Acceptance - - - - - JOHN W. DAVIS

"America" - - - - Massed Bands

Benediction - - - Very Rev. P. H. McDermott
Pastor Church of Immaculate Conception

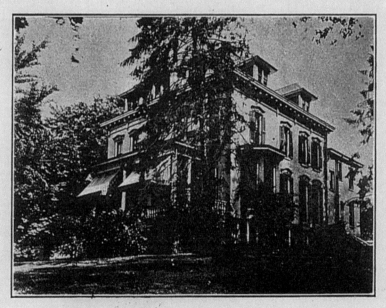

HOME OF JOHN W. DAVIS IN CLARKSBURG, W. VA.

A photograph of the home of John W. Davis in Clarksburg appears at the bottom of this page of the official program for the Notification Day Exercises in Goff Plaza on Monday, August 11, 1924. After a great parade attended by an overwhelming crowd, Davis gave his acceptance speech. The page includes a list of the parts of the program. (Courtesy of Rod Rogers.)

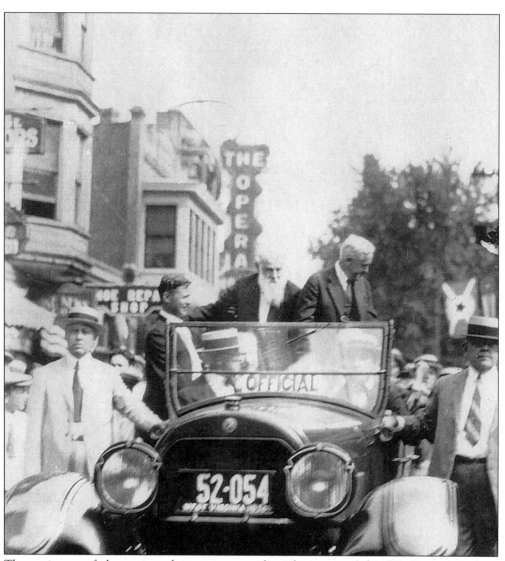

The main car of the motorcade carrying presidential nominee John W. Davis (standing, at right) proceeds up South Fourth Street on August 11, 1924, en route to his home three blocks away. That evening, Davis would deliver his acceptance speech before thousands of admirers from a stage set up on East Main Street in Clarksburg's Goff Plaza section. (Courtesy of Rod Rogers.)

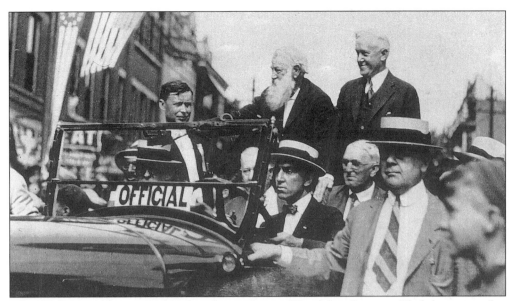

John W. Davis smiles appreciatively at bystanders on West Main Street in Clarksburg, just after turning from Fourth Street. To his right is his bearded political mentor, John C. Johnson of Bridgeport. Davis's bodyguard, William Nye, steers the official car on the way to the Davis home place a short distance away.

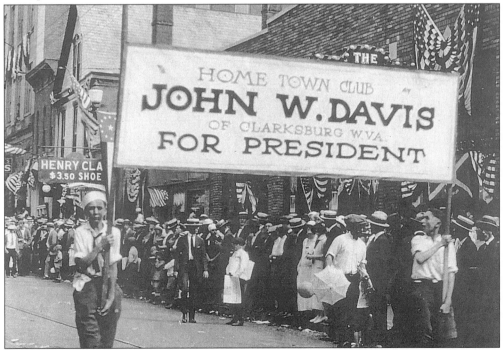

These youngsters carry the Home Town Club's banner touting Clarksburg native John W. Davis. Having been nominated by Democrats to face Republican Calvin Coolidge in the race for president, Davis was welcomed by one of the biggest crowds ever to assemble in Clarksburg. Here they are marching in the 300 block of West Pike Street, preparing the way for the motorcade.

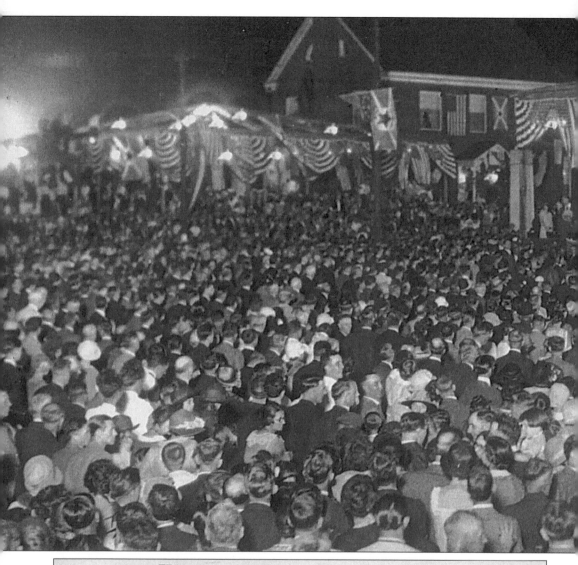

The John W. Davis Homecoming Committee

beg to acknowledge your generous contribution, which with the splendid co-operation given, has enabled us to make this welcome both a fitting tribute to Mr. Davis and an epoch in the history of Clarksburg and West Virginia.

Hugh Jarvis,
Treasurer

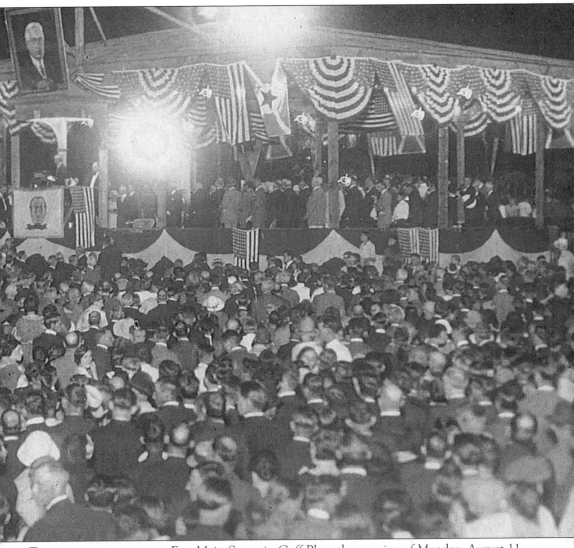

Two stages were set up on East Main Street in Goff Plaza the evening of Monday, August 11, 1924, for presidential nominee and Clarksburg native John W. Davis to deliver his acceptance address. The huge crowd is evidence of the candidate's popularity. The presiding officer for the ceremonies was Clement L. Shaver, chairman of the Democratic National Committee. The official notification statements were given by Senator Thomas J. Walsh, chairman of the Presidential Notification Committee. (Courtesy of Rod Rogers.)

The note of acknowledgment (on the facing page) from the John W. Davis Homecoming Committee was sent to contributors to the welcoming efforts in Clarksburg. The note reflects the date of August 12, 1924—the day following Davis's acceptance speech—and was signed by committee treasurer Hugh Jarvis. The occasion was a major milestone in the history of Clarksburg. (Courtesy of Rod Rogers.)

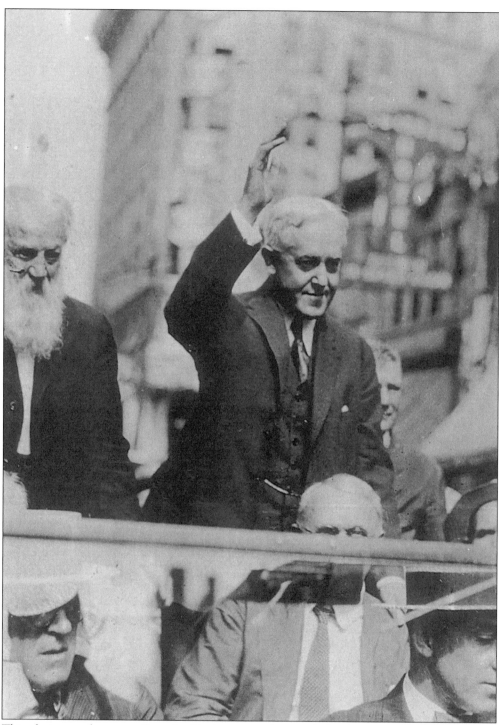

This photo, another scene from the Davis motorcade, concludes this special feature dedicated to presidential nominee John W. Davis, waving to a huge throng of onlookers lining West Main Street. His political mentor John C. Johnson stands with him, as he did throughout the campaign. In the background is the Empire National Bank Building. (Courtesy of Rod Rogers.)

Six

BUSINESS AND INDUSTRY
THROUGHOUT THE YEARS

The bricks and mortar of the foundation of Harrison County—its businesses and industries, which provide jobs for its residents—were more trustworthy in the area's earlier years. Even with the many problems and lost jobs caused by the Great Depression, working people could count on their employers to treat them as human beings rather than exploit them. There was a time some will recall when numerous factories were in operation in Harrison County, most manufactured glass and glass products. There were also several deep bituminous coal mines in sections of Harrison County, and there was always the Baltimore & Ohio Railroad.

Downtown Clarksburg and the shopping districts in towns like Shinnston, Salem, and Bridgeport, once beehives of activity, would eventually lose much of the business they once enjoyed with the advent of shopping centers and malls in North Central West Virginia. Today, more than glass and coal, the major employers in Harrison County are the aviation facilities at Benedum Airport and Industrial Park, the Federal Bureau of Investigation's Criminal Justice Information Services, and United Hospital Center. Featured in this chapter are images of factories and businesses that some will fondly remember, but others will have only been told of by their parents and grandparents.

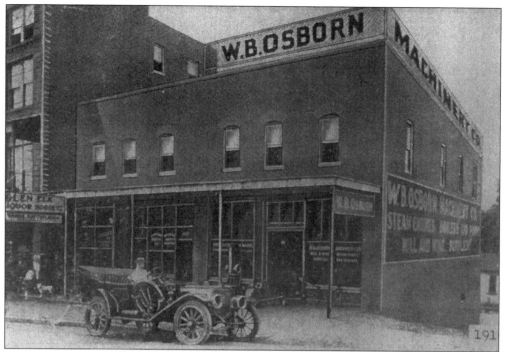

Back in 1910, W.B. Osborn Machinery Co. dealt in steam engines, boilers, and pumps, as well as mill and mine supplies at its location at 424 North Fourth Street in the Glen Elk section of Clarksburg. (Courtesy of Philip's Restaurant, Clarksburg.)

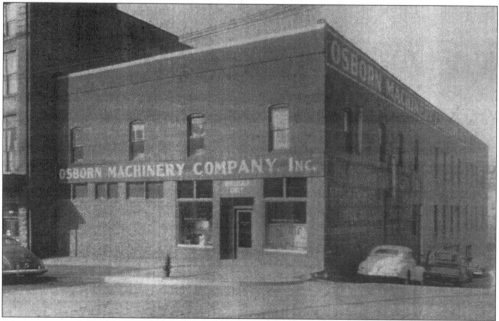

The exterior of Osborn Machinery Co., Inc. had been modernized considerably in the 40-plus years since the top photo was taken. This is a 1953 photograph. The company's slogan at that time and for years later was "Quality and Service - A Tradition for Over Three-Quarters of a Century. (Courtesy of Philip's Restaurant, Clarksburg.)

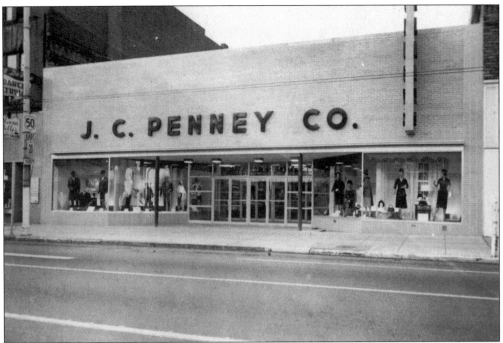

A few years after fire destroyed the familiar Arcade Building, which was a popular shopping Mecca in downtown Clarksburg for a long period of time, the J.C. Penney Co. established a store at the site. When the company moved its store to the Meadowbrook Mall in Bridgeport, it dealt a tough blow to the central business district. This photograph was taken in 1962. (Courtesy of Bob Nichols.)

Pictured here in 1910, the pottery plant works in Bridgeport were located a short distance behind the existing fire station, according to Bob Nichols of the Bell Studio in Bridgeport. Little other information is available about this industry. (Courtesy of Bob Nichols.)

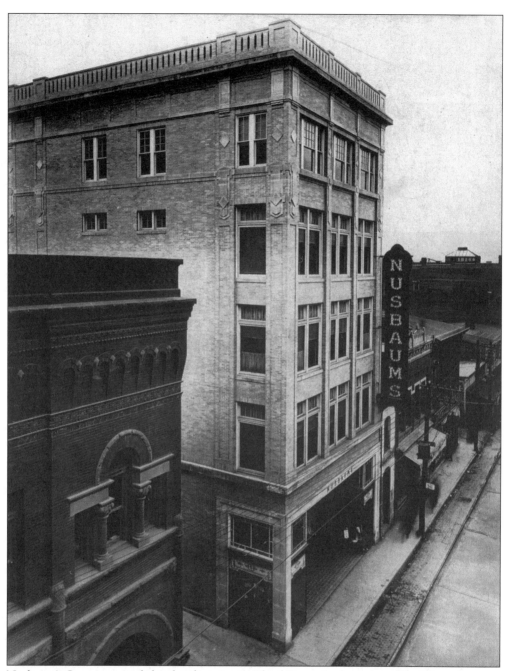

Nusbaum's Store occupied this familiar site on Third Street in downtown Clarksburg for years before Broida's women's clothing store was located there. At left is the red stone-and-brick Merchants Bank Building. Virtually all of the buildings seen here remain standing today, although somewhat modified. (Courtesy of the Harrison County Historical Society.)

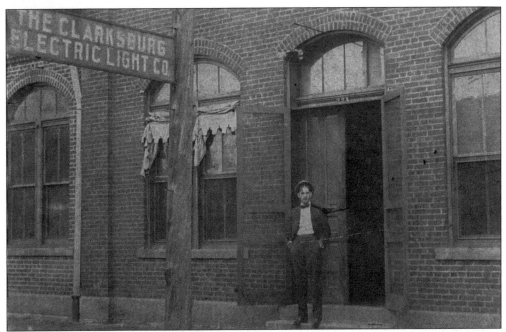

The Clarksburg Electric Light Company was begun in 1887 by Charles M. Hart, according to Dorothy Davis in her 1970 publication, *History of Harrison County*. She pointed out that he had insisted that electric streetlights would be more effective than gas lights. It turned out he was right. (Courtesy of the Harrison County Historical Society.)

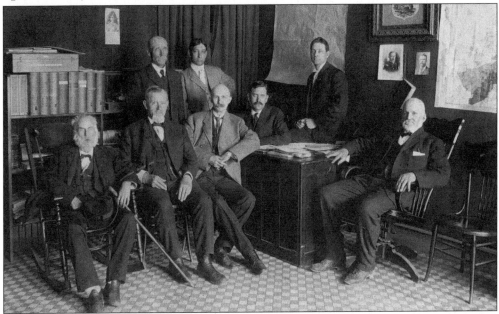

The directors of the West Fork Glass Co. in Clarksburg posed for this photograph. Only the last names of the directors were available and included Stewart, Davis, Cunningham, Shuttleworth, Randolph, Robinson, Bowen, and Stout. The company was founded on June 30, 1905, in the Industrial section of Clarksburg, where Eagle Convex Glass would later be located. The company went out of business in 1920. (Courtesy of the Harrison County Historical Society.)

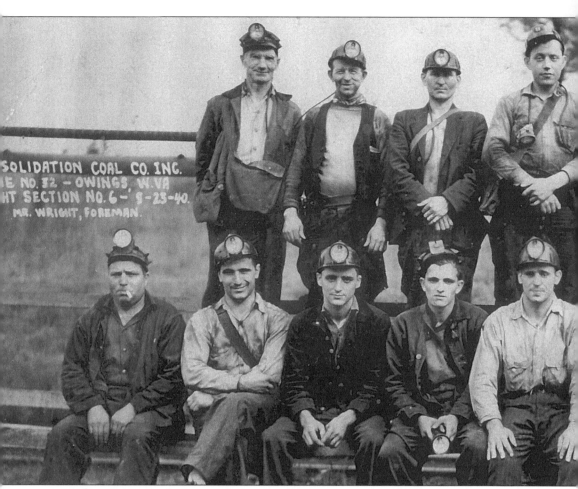

A Mr. Wright was the foreman of this group of Consolidation Coal Co., Inc. miners from Mine No. 32, Owings, near Shinnston. They represented Night Section No. 6. The photograph was taken on September 23, 1940, outside the mine by the Tallent Photo business. The miners were

The Carnation Milk Company, once quite a familiar site in Harrison County, had its plant just off U.S. Route 50, west of Clarksburg, near Wilsonburg. A number of individuals were employed at Carnation, but the plant closed its doors permanently in the 1960s. (Courtesy of Rod Rogers.)

98

not identified, nor was the foreman Mr. Wright. (Courtesy of John Tate, owner of Tate's Fruit Market, Meadowbrook.)

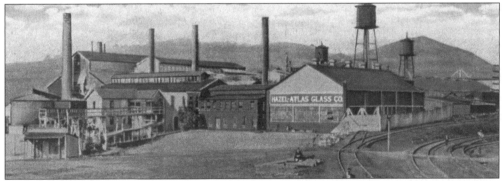

Hazel Atlas Glass Co. works stood along the Baltimore & Ohio Railroad tracks that passed over Sycamore Street in Clarksburg. In the mid-1950s, the plant was acquired by Continental Can Company, by Brockway Glass in the late 1960s, and eventually by Anchor Hocking Glass Company in the early 1980s. The plant, one of Harrison County's largest employers, closed in November 1987, putting more than 900 people out of work. (Courtesy of Eugene Jaumot of Bridgeport.)

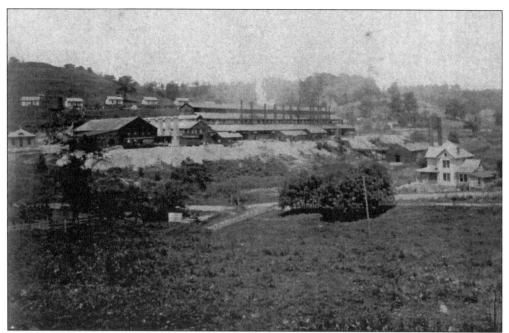

This photograph shows the distant Tinplate factory that was located between Pinnickinnick Addition in Clarksburg and Summit Park. Author Dorothy Davis points out that of the 500 Greek families who settled in Summit Park to be near the steel mill, 100 of them stayed in the county after the mill moved to Weirton. (Courtesy of Hobart H. Campbell of Clarksburg.)

These are some of the workers at the Tinplate factory near Summit Park. The company's full name was the Jackson Sheet and Tin Plate Company, and it was incorporated in July 1901. It was renamed the Phillips Sheet and Tin Plate Company in 1905, and the general offices moved to Weirton in 1910. (Courtesy of Hobart H. Campbell of Clarksburg.)

Here is yet another view of Phillip's Sheet and Tin Plate Company near Clarksburg. The name of the company was changed once again—to Weirton Steel Company. But in the late 1930s, the company discovered that with more modern methods of producing steel, the plant in Clarksburg proved so unprofitable that the business had to leave the area. (Courtesy of Eugene Jaumot of Bridgeport.)

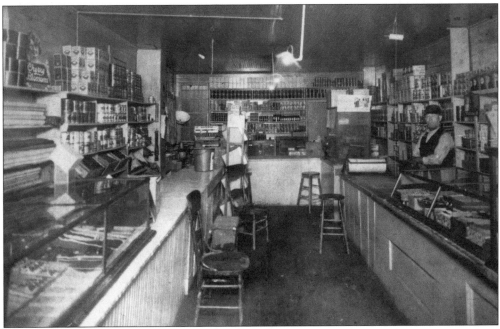

General merchandise was sold at the Newton Wright store in Bridgeport. Shown in this photo is the interior of the business. The man standing at right is believed to be Newton Wright, but this could not be confirmed. (Courtesy of Bob Nichols.)

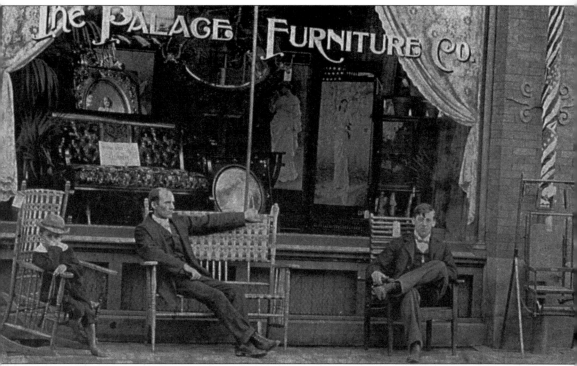

The Palace Furniture store in Clarksburg was incorporated as the Palace Furniture and Undertaking Co. on May 12, 1906. Located at 221 West Main Street in downtown Clarksburg, it is pictured here in 1910, with the D.M. Ogden dry goods and notions store located next door. In that period, furniture companies and woodworkers also served as undertakers. Palace

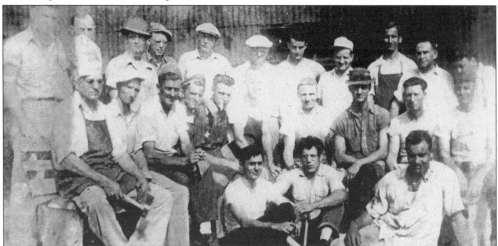

This photograph was taken in front of the Rolland Glass box shop, a manufacturer of window glass, in Clarksburg's North View section. From left to right are (front row) Tony Martino, Frank Altovilla, and Carmen Roberti (with cigar); (middle row) Tony Deluca, Jim Cochran, Berle Elliott, Andy Bolle, Travis Swiger, Ed Gabbert, U. Dehaute, Tom Veltri, John Hickman, and Stanley Stalensky; (back row) Berdine Caussin, J. Costello, Billy Gabbert, Jake Gabbert, Walter Gabbert, Danton Caussin, Robert Insani, Carl Somazze, John Stalensky, Frank Bokey, and B.G. Granato. (Courtesy of John Stalensky of Clarksburg.)

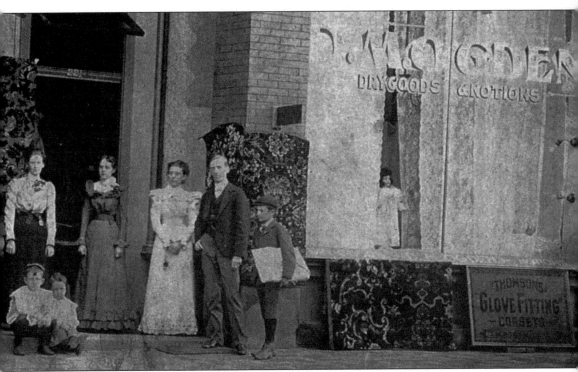

remained in business for many years, until the late 1970s or early 1980s, when a number of federal agencies opened offices in the building. The offices of the Harrison County Chamber of Commerce are located there today. (Courtesy of the Harrison County Historical Society.)

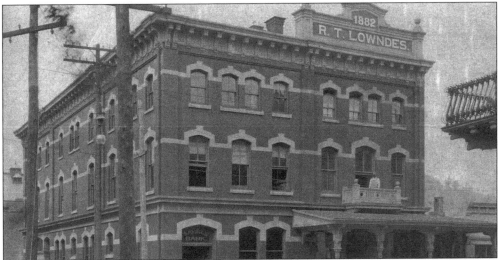

The R.T. Lowndes Savings Bank and Department Store, shown in this 1902 photo, opened for business in 1882, as indicated at the top of the three-story building, which stood at the corner of West Main and Third Streets in downtown Clarksburg. The bank building evolved over the years. Parsons-Souders Department Store would be located where the Lowndes store once was. In the 1960s, a new granite-faced building was constructed at the corner. The bank moved to the northeast corner of West Pike and Third Streets in 1965. (Courtesy of the Harrison County Historical Society.)

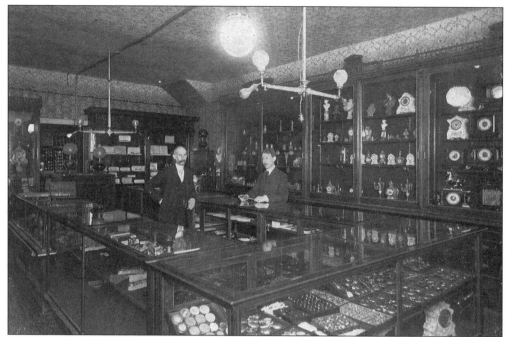

The interior of the F.A. Robinson & Son Jewelry Store, shown in this 1903 photo, opened its doors in the 1870s at 322 West Main Street in Clarksburg. The store was on the northern side of West Main, approximately halfway between Third and Fourth Streets. (Courtesy of the Harrison County Historical Society.)

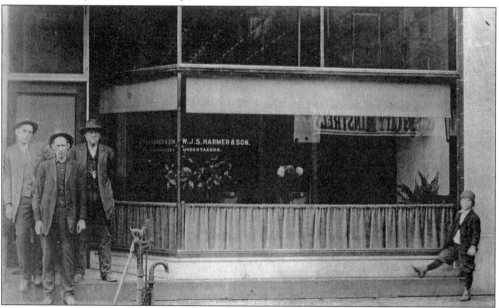

Three men and a child stand in front of the W.J.S. Harmer & Son Undertakers in Shinnston in 1914. The business was established "downtown" on Pike Street in Shinnston. William J.S. Harmer and Tyson B. Harmer Jr. performed much of their work in the home until the influenza epidemic of 1918–1919, according to Dorothy Davis in *History of Harrison County*. (Courtesy of Harrison County Historical Society.)

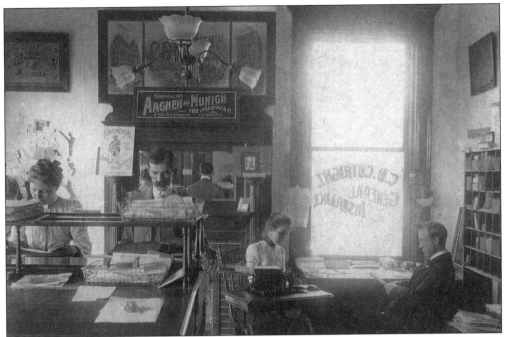

This photograph shows the interior of the C.B. Cutright General Insurance Co. office. Note the wheelchair/desk where the young woman is seated. As the signs on the wall indicate, the firm sold Aaghen and Munigh Fire Insurance and Continental Fire Insurance, as well as other policies. (Courtesy of Harrison County Historical Society.)

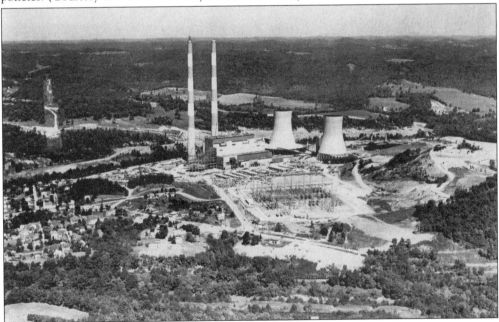

This is an early 1970s aerial view of Monongahela Power Company's (now Allegheny Power Company) Harrison Power Plant at Haywood taken by the late Edwin G. Propst of Clarksburg Engraving Co. Construction on the plant began in the late 1960s. It is one of Harrison County's largest employers. (Courtesy of Joyce Propst.)

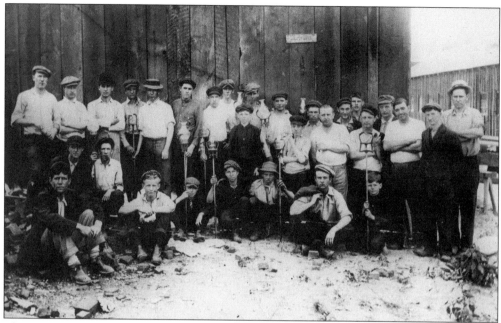

These "ware boys," photographed at about the turn of the twentieth century, were employed by the Bridgeport Lamp Chimney Company, which was established in the city in 1904. Approximately 6,000 lamp chimneys were turned out per day. The chimneys were made from a heavy form of glass for oil lamps. (Courtesy of Bob Nichols.)

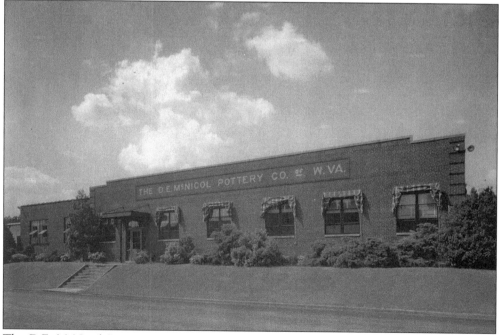

The D.E. McNicol Pottery Co. of West Virginia was located on Water Street in Norwood, which later became Stonewood. Also known as McNicol China Co., it was next to the Pittsburgh Plate Glass plant and contained seven kilns. In 1967, the business became the McNicol-Martin China Co. (Courtesy of Harrison County Historical Society.)

Seven

BODY, MIND, AND SPIRIT

There was a time in Clarksburg and Harrison County when there was a choice between at least two general hospitals, plus the Veterans Administration facility that opened in late 1950 and is now the Louis A. Johnson Veterans Administration Medical Center. In early 1977, United Hospital Center joined the existing complex along U.S. Route 19, south of Clarksburg. Before that time, "UHC" occupied the 18-year-old Union Protestant Hospital and St. Mary's Hospital in downtown Clarksburg as South Division and Downtown Division, respectively. The consolidation made it the first time in many years that there was just one public hospital in the county.

Where public schools in Harrison County are concerned, less than half a century ago, there were at least a dozen high schools, as many junior high schools, and about four dozen or more elementary schools. Consolidation over the years has dramatically reduced the number of schools. Salem College, which was established in the late 1880s, is the only four-year college based in Harrison County. Having merged with Teikyo University in Japan, it is now Salem-Teikyo University.

Although there has been a drastic reduction in the number of schoolhouses in Harrison County, the number of churches has neither appreciably increased nor decreased much over the years. Many new buildings have gone up and new non-denominational churches have formed, but a number of other church buildings have been vacated, too. At least one major church met a tragic end: the First Methodist Church in downtown Clarksburg was destroyed by fire on September 4, 1951.

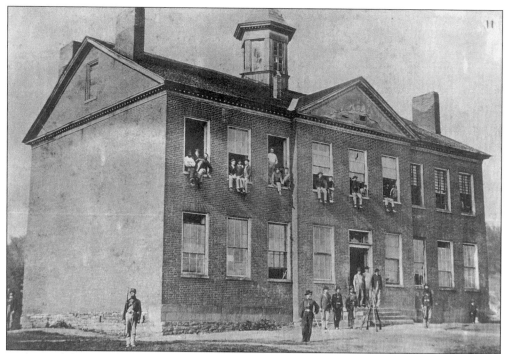

Armed sentries stand guard outside the Northwestern Virginia Academy, incorporated by an act of the Virginia Assembly in March 1842, in the mid-1840s. It was agreed upon by the trustees of Randolph Academy that the previous building be destroyed. The building shown above was built and completed in time to open in October 1843. (Courtesy of Harrison County Historical Society.)

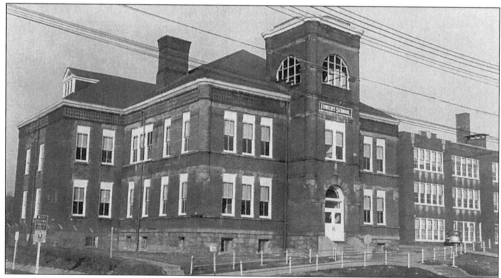

The building above is Towers Elementary School and stood at the site of the Northwestern Virginia Academy. The school was named for the Reverend George Towers, an educator at the former Randolph Academy, and opened in the 1890s under the name Clarksburg Public School. Towers School was demolished in the late 1980s. Central Junior High School, shown to the right, closed at approximately the same time, but the building still stands today.

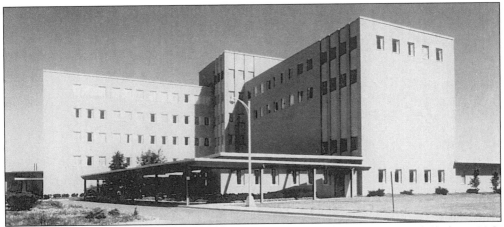

The new Union Protestant Hospital (UP) opened in December 1960 atop a hill above U.S. Route 19, south of Clarksburg. The old United Protestant Hospital had also been known as the Mason Hospital, and years before that, as the Kessler Hospital. Following considerable expansion, it was decided in 1970 that UP and St. Mary's Hospital would be consolidated under the name United Hospital Center, Inc. (UHC). The nearly 10-year-old UP Hospital became UHC South Division and St. Mary's became Downtown Division. After further expansion, the facilities were combined into one complex. (Courtesy of Suzanne Hornor, public relations director at United Hospital Center.)

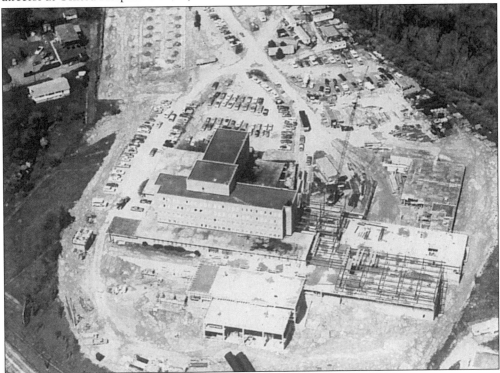

United Hospital Center has often been the site of considerable construction activity in the past quarter-century. This work was underway in 1975. The square plot of ground (top left) is now occupied by a four-level parking garage for hospital personnel and visitors. (Courtesy of Suzanne Hornor, public relations director at United Hospital Center.)

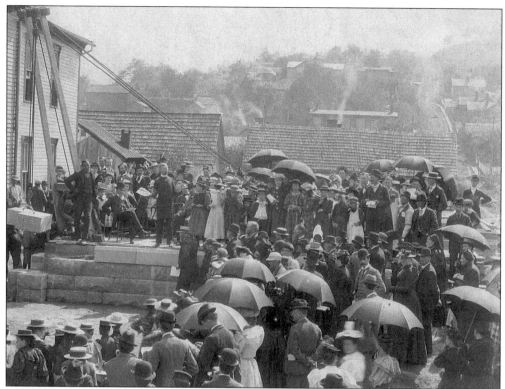

These folks had a rainy day on September 27, 1893 for the laying of the cornerstone for the First Presbyterian Church, which was to be located on West Main Street at the corner of South Second Street. The church was dedicated on June 17, 1894. Westminster Hall, the church's educational building, opened in 1952. Seen hazily in the background is Lowndes Hill. (Courtesy of Harrison County Historical Society.)

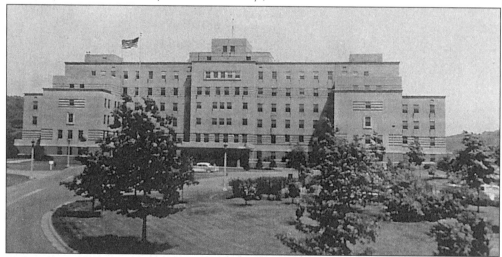

Here is the way the Veterans Hospital looked in the late 1950s. New additions were made in the 1990s. Ground was broken for the hospital in April 1948, and upon the completion of construction, it opened in December 1950. An access road with bridges connecting U.S. Route 19 and the Mount Clare Road was also built. Veterans Memorial Park is located nearby.

110

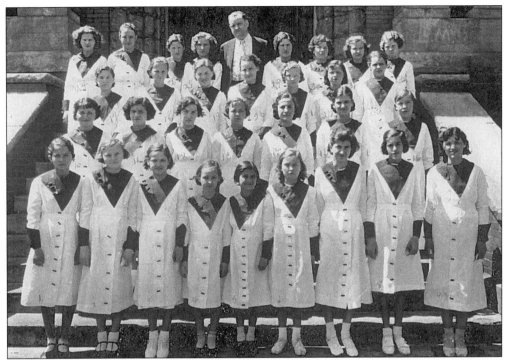

Shown here are members of the North View Junior High School Glee Club in 1934. The director, seen in the center of the back row, is Mr. Bickett. The school was located on North Nineteenth Street in North View. (Courtesy of Pamela Guice, whose mother, Christine Richards Steele, appears in the second row, fourth from left.)

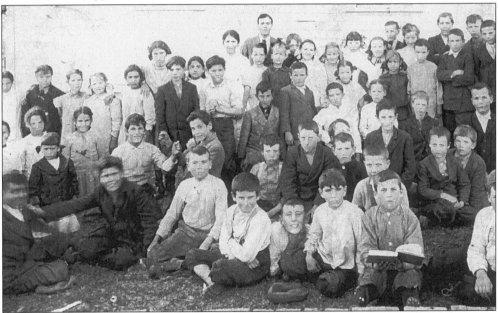

These students attended the grade school at Grasselli (later Anmoore) in the early 1900s. The students included many children who had emigrated from Spain and who had little knowledge of English. (Courtesy of Anita Menendez of Spelter.)

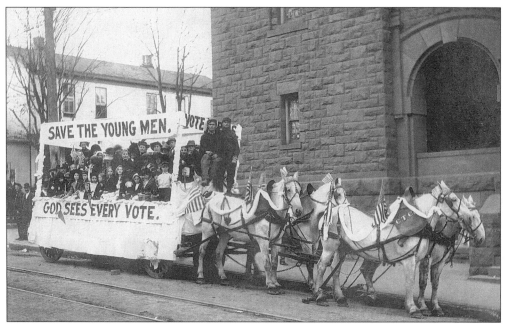

This group of individuals got aboard the horse-drawn prohibition "bandwagon" in front of the old First Methodist Church on West Pike Street when West Virginia "went dry." The printing on the wagon shows the support shown by the people for prohibition. (Courtesy of the Harrison County Historical Society.)

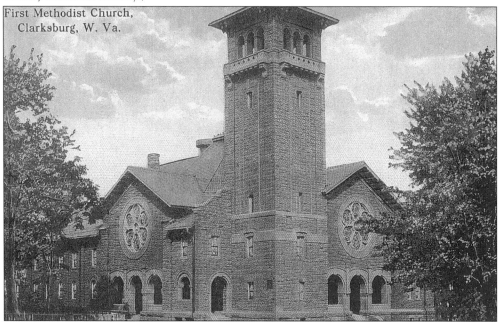

This photograph shows the brownstone First Methodist Church as it appeared in 1909. It was located at the corner of West Pike and North Second Streets in downtown Clarksburg but was destroyed by fire in September 1951. The building was subsequently replaced by a modern stone church, which is now the First United Methodist Church. (Courtesy of the Harrison County Historical Society.)

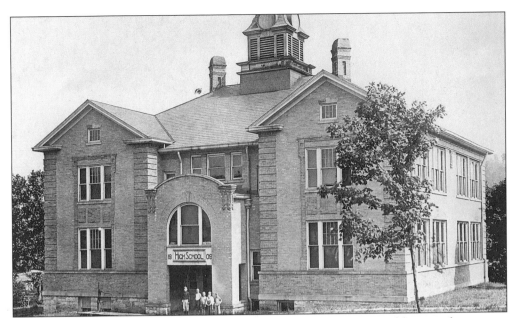

Bridgeport High School has known several homes, and the site pictured here is where it was located in the early twentieth century, on what is now Worthington Drive. Years later, the high school was located near the top of Newton Street. Then, when it moved to Johnson Avenue in 1963, Bridgeport Junior High School occupied the just-vacated school. Today, the high school and junior high, as well as Johnson Elementary, are located on Johnson Avenue. The building above became the site of Simpson Elementary School. (Courtesy of Bob Nichols.)

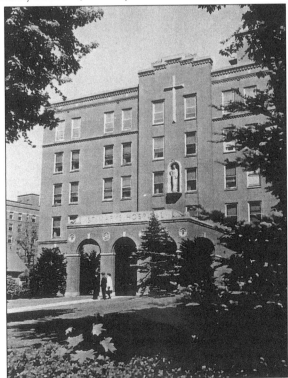

St. Mary's Hospital is shown here at its location at the corner of South Chestnut Street and Washington Avenue. DeSales Hall, where the St. Mary's School of Nursing was located, is visible in the left background. A smaller St. Mary's Hospital was once located on Washington Avenue. St. Mary's became Downtown Division of United Hospital Center in 1970 and this building was demolished in early 1977 after all UHC operations were consolidated into the current facility along U.S. Route 19.

This team picture of the Ziesing Junior High School football team was probably taken in the 1930s, and the members of the team are not identified. (Courtesy of Benjamin Quinones, a resident of Spelter [formerly Ziesing], and submitted by Anita Menendez, also of Spelter.)

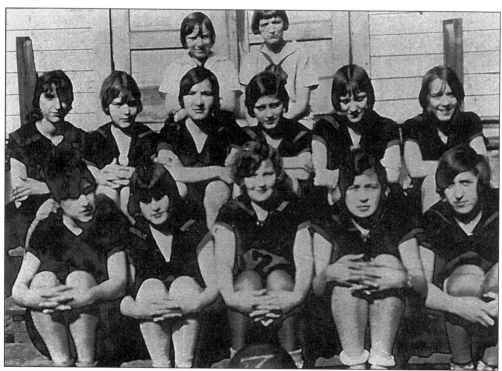

The Ziesing Junior High School girls basketball team of 1929 appears in the photo above. Members of the team are unidentified. (Courtesy of Anita Menendez of Spelter.)

Eight

IMMIGRANTS AND ANCESTORS

Since the beginning of the twentieth century, the scourge of communism and the dictatorships of Hitler, Mussolini, and others have spurred an unprecedented immigration of foreigners into the United States in hopes of getting a piece of the American dream. West Virginia would become home to hundreds of people of Scottish, Irish, German, Italian, Greek, Spanish, and Belgian descent, among others.

In Harrison County, a number of Italian immigrants would eventually settle largely in Shinnston and Clarksburg areas. Some people of Hispanic nationality found homes in Ziesing (later Spelter), where the Matthieson & Hegeler Zinc Co. plant was located, and in Anmoore, where the National Carbon Company (now UCAR) was located. Immigrants from Greece established a community in the Summit Park area and many worked at the Weirton Steel/Phillip's Tin Plate factories. Those of Belgian origin still tend to be associated with the Adamston and North View sections of Clarksburg. Many found jobs as glasscutters at the Adamston Flat and Rolland glass plants, and at the Hazel Atlas Glass facility. Still others settled in the Salem area.

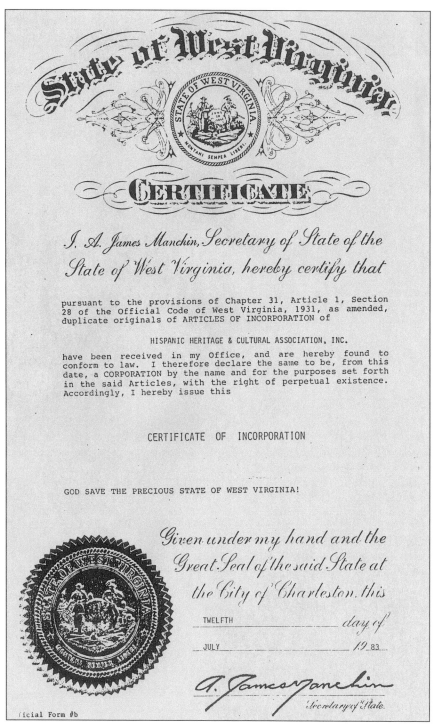

State of West Virginia

CERTIFICATE

I, A. James Manchin, Secretary of State of the State of West Virginia, hereby certify that

pursuant to the provisions of Chapter 31, Article 1, Section 28 of the Official Code of West Virginia, 1931, as amended, duplicate originals of ARTICLES OF INCORPORATION of

HISPANIC HERITAGE & CULTURAL ASSOCIATION, INC.

have been received in my Office, and are hereby found to conform to law. I therefore declare the same to be, from this date, a CORPORATION by the name and for the purposes set forth in the said Articles, with the right of perpetual existence. Accordingly, I hereby issue this

CERTIFICATE OF INCORPORATION

GOD SAVE THE PRECIOUS STATE OF WEST VIRGINIA!

Given under my hand and the Great Seal of the said State at the City of Charleston. this

TWELFTH day of

JULY 19 83

A. James Manchin
Secretary of State.

ficial Form #b

On July 12, 1983, West Virginia Secretary of State A. James Manchin signed this Certificate of Incorporation for the Hispanic Heritage & Cultural Association, Inc. Since that time, the association has played an active role in Harrison County. (Courtesy of Anita Menendez of Spelter.)

Sergio Menendez, 23, and Lourdes Lorenzo, 21, of Anmoore were married on October 10, 1920, at St. John's Catholic Church in Clarksburg. Both are of Spanish descent. (Courtesy of Anita Menendez.)

Nicanor Lorenzo came to America on June 28, 1920, on the SS *La Savoie*. He originally settled in Grasselli, which is now Anmoore. (Courtesy of Anita Menendez.)

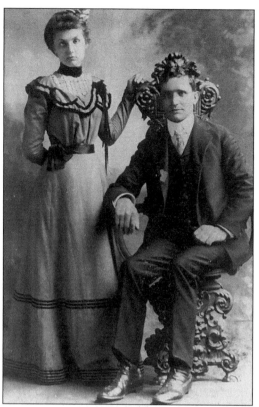

Jules Alexander Jaumot, who was born in Belgium on May 2, 1872, was married to Marnie Mary Smith Jaumot, born in Louisville, Kentucky on July 18, 1884. Marnie died in Clarksburg on May 31, 1930, and Jules died in Essex, Maryland on October 12, 1942.

Shown in the photograph below are Joseph and Denise (Martin) Coenen. The couple came to the United States and to West Virginia from the city of Jumet in Belgium. (Courtesy of Lillian Crites of Bridgeport.)

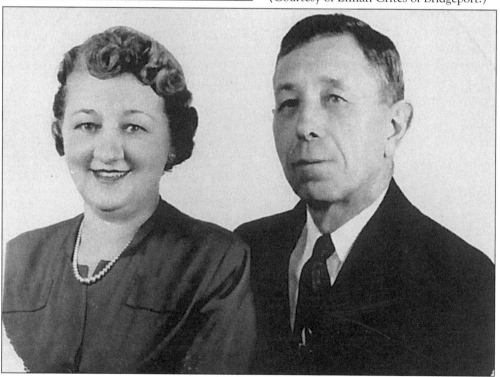

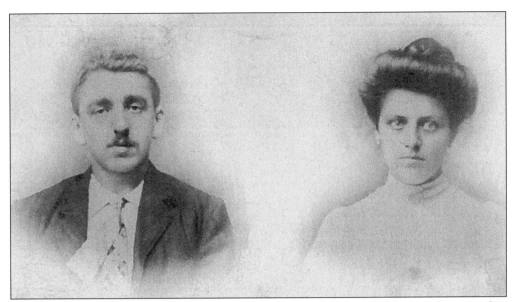

Jumet in Belgium was also the hometown of Josephine and Valentine Martin, who arrived in Harrison County in the early twentieth century. (Courtesy of Lillian Crites of Bridgeport.)

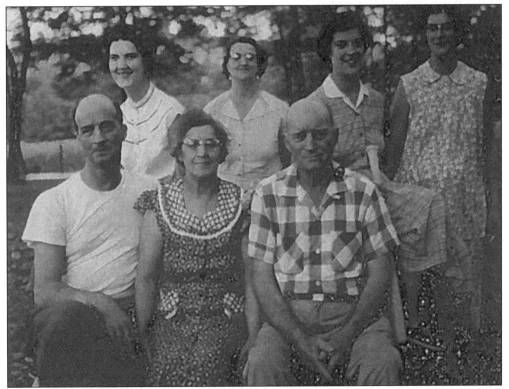

Members of the Jules Charles family are pictured here. Jules Charles (smoking a pipe) and Jennie Andre Charles (to his immediate right) are both of Belgian ancestry. Jules worked at Lafayette Glass in the early 1900s and later worked at Rolland. All three men shown in the photo were glasscutters at Rolland. (Courtesy of Freda Kovalan of Clarksburg.)

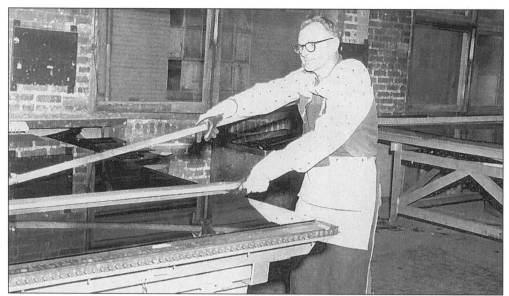

Rene Zabeau is shown in this photograph in the late 1940s cutting glass at the Pittsburgh Plate Glass Co. plant in Norwood (now Stonewood). Now deceased, Zabeau was also of Belgian ancestry. (Courtesy of Mr. Zabeau's daughter, Vicki Zabeau Bowden of Clarksburg.)

In this 1980s photograph, Rene Zabeau (left) and the Reverend Father Jean Ducat examine an envelope in which a videotape has been packed. This photograph was taken just prior to the time the Belgian Society was established in Harrison County. (Courtesy of Vicki Zabeau Bowden of Clarksburg.)

These glasscutters, representing the unions of the various glass companies in the Harrison County area, were of Belgian ancestry, according to Eugene Jaumot of Bridgeport. Mark Markham (standing, second from right) of Clarksburg was serving at the time of the photo as the organization's national president. Others identified are Albert Noe, seated second from left; Harry Tanzey, seated at far right; Merle Duchess, standing at far right, and Jaumot, standing third from left. (Courtesy of Eugene Jaumot of Bridgeport.)

Alphonse and Clara Coenen, also from Jumet, Belgium, are shown standing on the porch of their home some time during the early part of the twentieth century. (Courtesy of Lillian Crites of Bridgeport.)

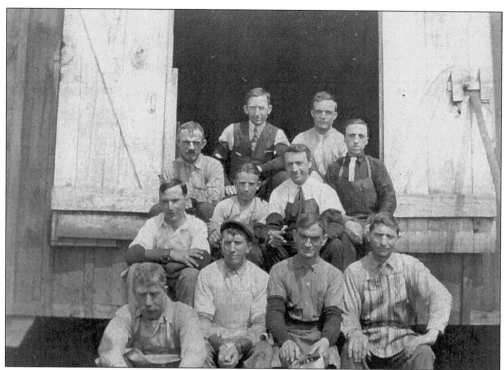

This photo was taken in 1910 at the old West Fork Glass Company that once operated in Clarksburg. The boss cutter was Jules Jaumot, the seated man wearing the striped apron. (Courtesy of Mr. and Mrs. Eugene Jaumot of Bridgeport.)

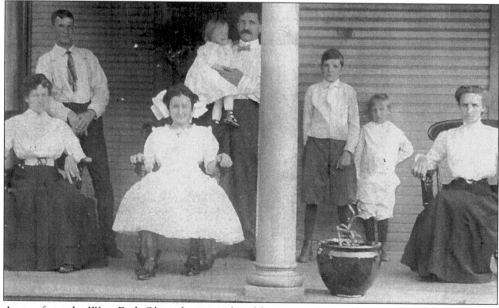

Across from the West Fork Glass plant was the old company house. Among those shown on the porch, all of Belgian descent, are Mrs. Mamie Jaumot, Edith Jaumot, Aunt Alice and Uncle Ollie Ruthey, Frank Jaumot, Jules Jaumot Jr., and Jules Jaumot Sr. (holding his daughter Alice). (Courtesy of Mr. and Mrs. Eugene Jaumot.)

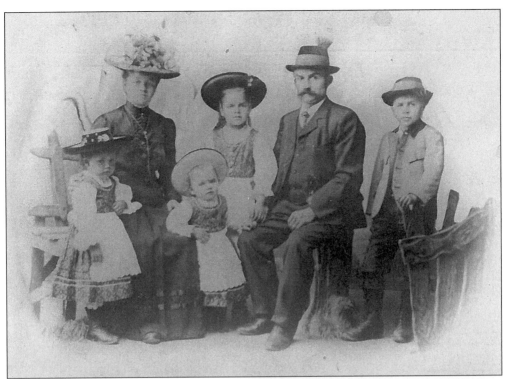

Members of the Joseph Melkus family, who arrived in the United States in 1912 from Germany, appear in this photograph. From left to right are Mary Melkus Taylor, Mary Melkus, Frieda Melkus Aiello, Margaret Melkus Bouchard, patriarch Joseph Melkus, and Joseph Witt Melkus. (Courtesy of Mr. and Mrs. Konrad Melkus of Bridgeport.)

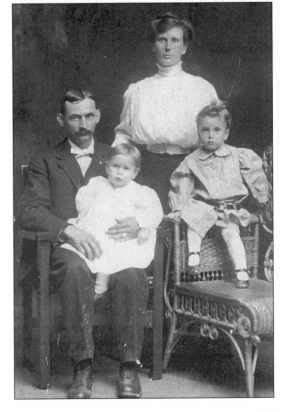

Members of the Michael Benjamin Criss family, of Irish ancestry, included Michael's wife, Della Mae Criss, and children Robert Hughes Criss (left) and Benjamin Michael Criss. The family resided in Clarksburg. (Courtesy of Nadine Criss Stealey.)

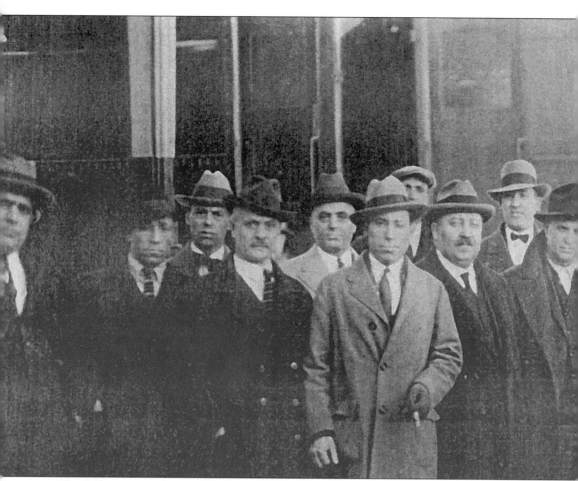

The Baltimore & Ohio Railroad station in Glen Elk provided the background for this 1920s photograph of the Sons of Italy. Members of the organization are not identified, but the

The well-known Tiano family of Glen Elk is shown here, gathered in the residence of one of its members. Shown standing at far right is "Hot Dog Bill" Tiano, who served the city as a policeman and fireman and was reportedly a nightclub operator. (Courtesy of Virgil LaRosa.)

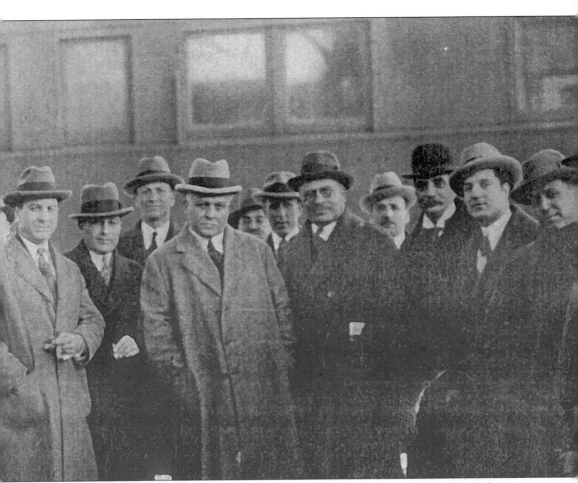

William Marconi Lodge of Sons of Italy does exist today and is headquartered on Baltimore Avenue. (Courtesy of Virgil LaRosa.)

This family had their picture taken in the United States in 1919, just after they arrived from Italy. Shown are Catherine Lonzante Oliverio, Mary Lonzante Belcastro, Victoria Lonzante Mascaro, Samuel Lonzante, and Samuel Mascaro. (Courtesy of Dave Oliverio of Clarksburg, the grandson of Catherine.)

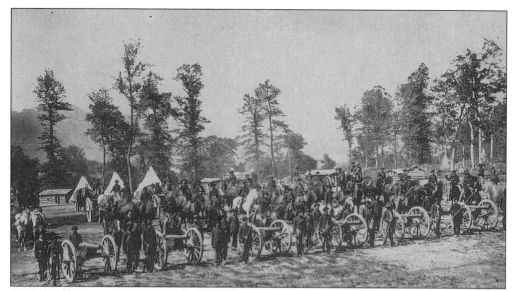

The "Corral Area" was located along what is now East Main Street between Park and Oak Streets and across from what is today the Davis-Weaver Funeral Home during the era of the War Between the States. These individuals comprise Moseby's Brigade. Circuses would unload their cars at the railroad station off West Pike Street and travel to the Corral to set up their tents before the circus parades. (Courtesy of the Harrison County Historical Society.)

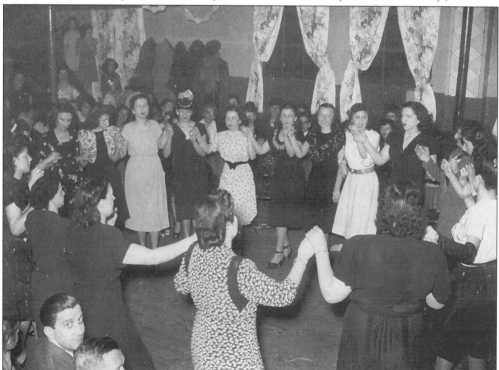

On March 25, 1946, these individuals from the Greek community in Summit Park held a celebration on Greek Independence Day in the Summit Park Community Center, next door to the St. Spyridon Greek Orthodox Church. (Courtesy of Angelo Koukoulis of Bridgeport.)

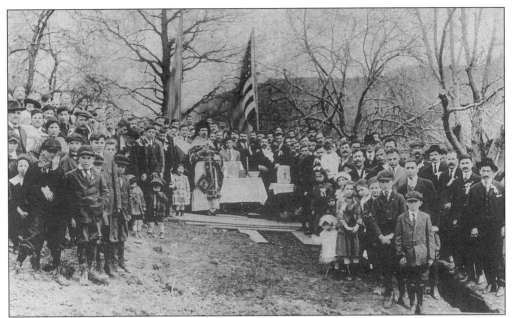

Very early in the twentieth century, there was a cornerstone ceremony at the St. Spyridon Greek Orthodox Church on Factory Street in Summit Park, and this crowd of people was in attendance. (Courtesy of Angelo Koukoulis of Bridgeport.)

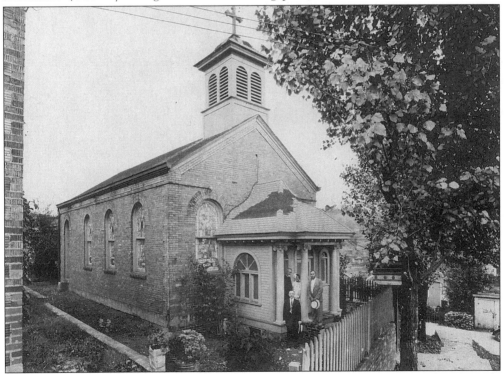

This is how the St. Spyridon Greek Orthodox Church on Factory Street appeared in the early 1930s. A number of Greek families through the years have worshipped inside this church. The individuals on the porch are unidentified.

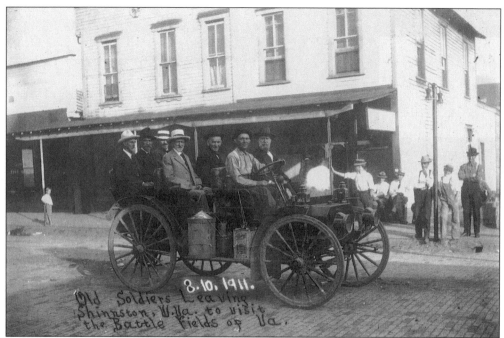

A group of old soldiers is shown in an early motor vehicle as they leave Shinnston to visit the battlefields of Virginia on August 10, 1911. The soldiers are not identified, nor is the building behind them. (Courtesy of the Harrison County Historical Society.)

The home of Colonel William M. Lowther, this cabin was located approximately 2 miles from West Milford in Harrison County on the north side of the West Fork River. Lowther became distinguished as "a skillful and courageous frontiersman for his unselfish devotion to the good of the colonists." (Courtesy of Bob Nichols.)